CONTENTS

Modes & Motivations . 2
Paths and Branches. 4
Practice-Led. 6
Creating and Disseminating New Culture 10
Human-Centered . 14
Engagement. 18
Scholarship and Research About the Arts 24
The Arts and Design in the Context of Academia 28
Design Research . 32
Topic Insights and Comparisons 36
Methods and Interpretation Notes 38
A Sample of Books and Articles About Arts Research. . 42
Follow-Up Questions for Understanding and Application 45

WHAT IS ARTS RESEARCH?
Modes & Motivations

MANY FACETS OF ARTS RESEARCH

There are books written about arts research. The topic lends itself to a wide array of interpretations that spring from the modalities, disciplinary affiliations, and critical perspectives of those doing the work to define it. What seems clear is that arts research is driven by social and material concerns, embedded in cognition and culture, and humanistic to its core. The practical goal and task of this research brief is to share a ground-up set of perspectives on arts research that can help in communicating the many facets and cultural frames in common use. The definitions and descriptions that emerge provide practical insight for articulating everything from job descriptions to economic policy, as well as tenure and promotion criteria, grant programs, and even the mission descriptions of institutions themselves.

The main task of this work is not to get the right answer; rather, it is to untangle and see the multiple paths and branches for their material and metaphysical commitments, how they are practiced, and what they mean as outcomes and experiences. The work here does not seek to describe an authoritative definition for arts research that can encompass all creative and scholarly pursuits. Nor does this research brief seek to advance a scholarly review of the subject. Instead, this work seeks to add to our understanding of how faculty, administrators, and students think about arts research within the institutional context of research universities.

As an array of topics, these categories can facilitate clearer communication and understanding. As categories, they can also essentialize the topics and help anchor them in minds and practices. The risk and reward of concrete categories and topics is that we begin to rely on the characteristics that makes them distinct and salient, while possibly ignoring richer descriptions. However, they also provide a better opportunity to build shared understanding of what constitutes arts research, especially among those people who may be new or unfamiliar with the domain. Categories can be powerful. Use them wisely. -gh-

> " For me, [arts research] involves exploring new ideas that arise as cultural ideas shift and change, and that arts need to sort of reflect and explore our changing world, not just technologically changing, but socially changing as well."

ASSOCIATE PROFESSOR AND CHAIR

THEATRE

> " Art research is a very problematic category. It's an interesting category. I'm still in the process of researching what art research might consist in and of. I don't find the word art applied to research to necessarily mean just one thing."

PROFESSOR

ART AND FILM AND MEDIA STUDIES

KEY TAKEAWAYS

Arts research means different things to different people, and definitions often contain multiple threads and topics.

Some topics for arts research are correlated, suggesting similarities in their mode of impact and how they are descibed.

Acknowledging and highlighting different modes and genres of arts research can be a valuable activity for building shared awareness and understanding.

The topic "Creating New Culture" is prevalent and well-shared across disciplines.

Even though people may use similar terms, their meaning and the traditions from which they have arisen may be distinct.

A useful approach may be to ask "When is arts research?," when working with collaborators and within academic institutions.

The main topics of arts research presented are likely to be stable over time, but the relative proportion and semantics may shift for different groups of people.

Some people's understanding of arts research includes a reflexive awareness of institutional culture, incentives, and norms— as demonstrated by the topic, "The Arts in the Context of Academic Research Culture."

Arts research includes humanities, social sciences, and natural sciences-driven research *about and through* the arts.

The topic of "Human-Centered" distinguishes responses in the Natural and Social Sciences disciplinary clusters from others.

Photo Credit: Arts Research Institute (ARI) at VCUarts

Paths and Branches
What is Arts Research?

The tree diagram to the right provides a draft folksonomy and map of the conceptual structure of arts research—based on the perspectives of university faculty, staff, academic leadership, and some students. This map emerged from a suite of statistical methods that discover, sort, and connect themes using the words of original texts, like interviews (see page 37 for detail on methods).

0.2

The branches show the relative proportion of topics for the definition of arts research and how those topics are correlated for 444 interview responses. Correlated topics are indicated by the connected branches, and the relative proportion of each topic in the entire set of responses is listed at each node, or as a sum of the combinations of topics at the parent nodes. Topic names are provided at the leaves of the tree. In the pages that follow, topics are presented in the order of greatest prevalence.

0.8

There are two main branches of this tree. The top branch contains 'Engagement' and 'Design Research'—both of which center on methods of knowing, and on involving others. The bottom trunk encompasses a diverse set of traditions and modes of research, with the most prevalent view (24%) that arts research is 'Practice-Led.' 'Practice-Led' refers to a material, social, performance-based, technological, and/or conceptual dialectic. It is driven by practice, and it is also aligned with a definition of arts research that is about 'Creating New Culture.' Research *about the arts* — such as art history or sociological studies of the arts — is quite distinct. 'Human-centered' describes arts research largely as a condition of being human. Finally (and perhaps somewhat cynically), arts research is *what artists do in the academic culture of research universities*.

- Engagement 0.1
- Design Research 0.1

0.43
- Practice-Led 0.24
- Creating and Disseminating New Culture 0.19

- Humanistic Scholarship and Social Scientific Research About The Arts 0.1

0.27
- Human-Centered 0.17
- The Arts and Design: In The Context and Culture of Academic Research 0.1

ARTS RESEARCH:
Practice-Led

FROM MATERIAL TO MASTERY

> " Arts research is exciting because it's a different way of learning things. You can actually use practice to learn. So it's not just going out and reading, it's not going into a laboratory and manipulating, it's using your own body to understand something. So, I'm speaking from a performance perspective, by actually doing something with your body, you can actually understand something new about the world."

ASSOCIATE PROFESSOR

MEDICAL ETHICS AND HUMANITITES

> " Well, I consider it a form of creative practice where inquiry happens. Asking questions, trying to see what happens if I think about the world this way, what happens if we combine these kinds of materials, what kinds of experiences can we create from thinking in a different way."

DISTINGUISHED PROFESSOR

DIGITAL HUMANITIES

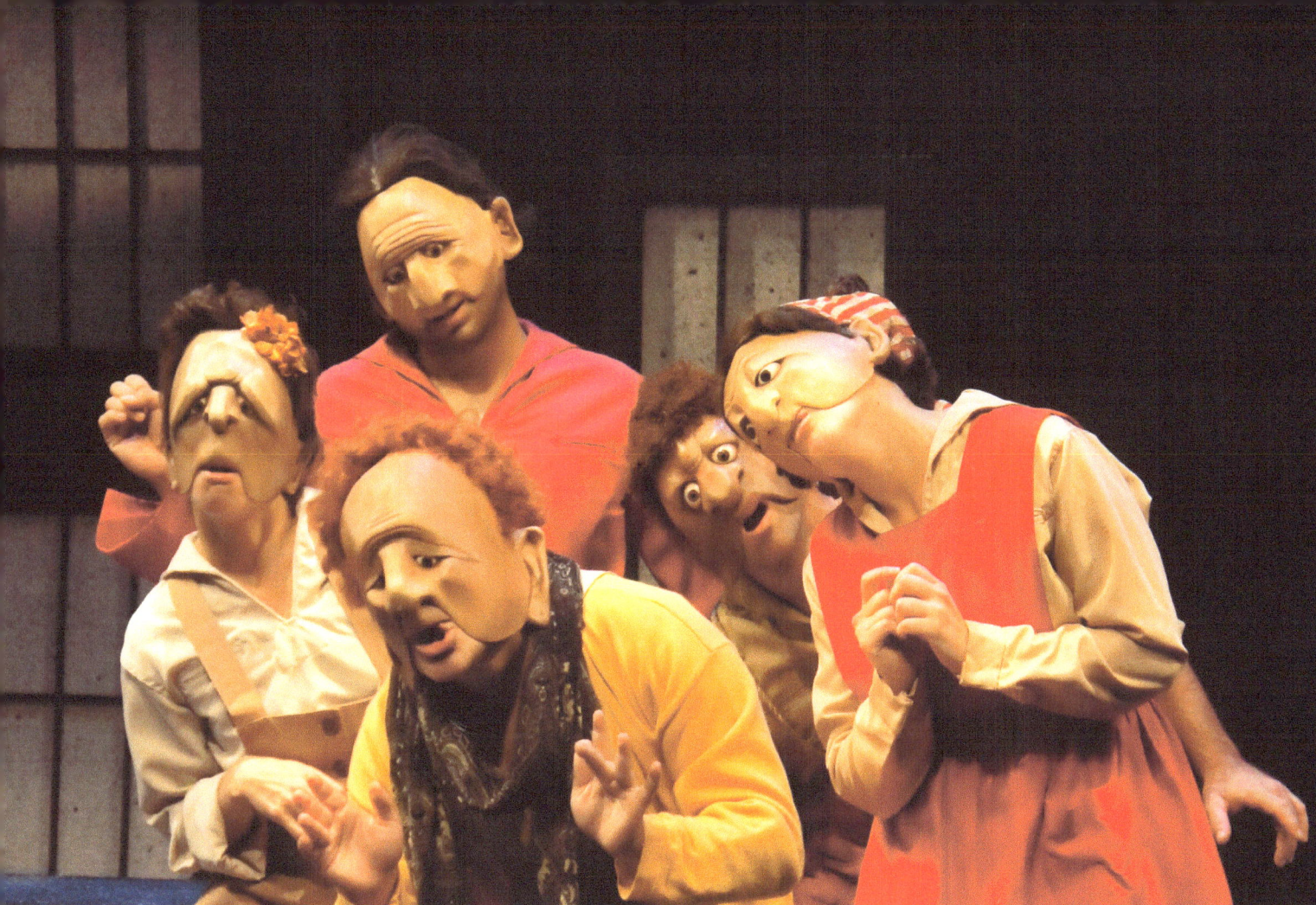

Above: Crescendo, an Iowa Partnership in the Arts production, was developed from a research project in which University of Iowa Department of Theatre Arts Associate Professor Paul Kalina sought to bring together a new form of masks and traditional mask-making by Italian mask creator Matteo Destro and original jazz compositions by University of Iowa Jazz Studies Director John Rapson. Director Paola Coletto and Destro expressed interest in exploring the theme of education in the United States and the collision of these improvisational forms along with this theme, allowed a modern audience to examine how the Industrial Revolution still impacts our educational system. Actors (from left to right): Valeria Avina, Chris Cruz, Ari Craven, Paul Kalina, and Allay Destro. Photo credit: R. Eric Stone, University of Iowa Department of Theatre Arts production photo.

Arts research takes many forms, and it is many things. It encompasses many disciplines. It creates new knowledge, and creativity is central. It is based in practice, and leads with practice.

"Arts research is also broadly defined. We have Humanists in art research who do performance study, history, musicology, theory, those sorts of things. We also have performing artists. People like dancers, actors, musical performers, sort of in the recreative realm, bringing works of art to life and doing so in an imaginative and creative way. We also have that generative class of people like choreographers and composers and playwrights and other artists as well who deal in the plastic arts or in performance arts of all different types. Arts research is an incredibly broad field, but those are, I would think, the major categories."

"I understand it to be anything that is creating new knowledge, new understandings, new practices around any of the arts disciplines and it is essentially pushing the envelope of practice or understanding in those disciplines. It could be via performance, it could be via choreography, it could be by historical research, etc."

"Actually no different from any other kind of research. I would say that arts research is producing new knowledge about a broad range of non-scientific kinds."

"The creation of new knowledge, the creation of new objects and the study of objects of art."

"I would, again, consider arts research to also be the production of those art objects and art works as well. There would also be a terrain in between that I would also be a strong advocate for, which would be the production of fundamentally new works, but

reflection upon that work and some sort of critical engagement with it."

"That gets a little trickier. It could be the kind of research that an artist in particular does in order to enhance his or her art form. For example, a painter who is going to investigate different styles or approaches to painting. I think in my case, I consider myself a writer, but I'm not a fiction writer. I mostly write nonfiction and in my case research can mean anything from going out and watching a bunch of John Ford films and analyzing them to doing the background or historical archive work that one would do for a scholarly approach to writing."

"I think it's a broad range perhaps with the word creative focus associated with it. I expect it might have a theoretical aspect depending what aspect of art that you are talking about. But it could be much more hands-on in the creation of new objects and entities that constitute a wide variety of things. But again, it could be music, it could be theatre, it could be physical art objects."

Practice-led arts research is exploration, technique, and integration—where materials, meanings, and relationships collide—requiring synthesis, craft, and practice. Practice-led research invokes friction, dialogue, and a dialectic between materials, between categories, between social relationships, between things, between activities, identities, vibrations, futures, adhesions, tensions, techniques, colors, collaborations, sensations, disciplines, politics, performances, and ways of knowing.

"Arts research can happen by what some practice, arts research can be done by investigating the practice of others but I will leave it always to the researcher to decide what arts research could be. In an example with that, that will be, if you look at the work of Josef Albers, Josef Albers worked in [color] did a lot of research before he ever applied pigment to paper; it was about colors and light, so that's one kind of research and we also do research of the artist himself so again I will leave the definition of research to the researcher."

"There is research on practice, there is research through practice. There is research on [inaudible 00:03:32], there is arts theory. I don't think these are necessarily continuous, or similar, I think that there are distinctions between all these different modes of research. I think, if we are talking about research that would be, seem to be making a contribution to knowledge. … it's in a, the way that the knowledge is codified because there is the artifact and then there is the thought and so the thought is transmitted, technically, via language so, therefore, I think that there can be practice-based research but that isn't the making of things, right? I think there is another aspect, which is the transmission and a dissemination of what has been learned about that and I think that's one of the major distinctions between some of the things that are happening under the banner of arts research."

"[T]he research of working artists is studio practice itself. It's an experiential knowledge-gathering which comes from power of hand as well as powers of mind."

"Well, I consider it a form of creative practice where inquiry happens. Asking questions, trying to see what happens if I think about the world this way, what happens if we combine these kinds of materials, what kinds of experiences can we create from thinking in a different way. I think that arts practice is really an interesting - Marcel Duchamp called his arts practice "laboratory experiments", so it's really interesting to see the difference, or the similarities in other words, between arts practice and other forms of research. I don't actually think they're very different."

"I have many opinions about arts research. I think there's the traditional studies view. It's the study of art, the study of how artists work, the study of artifacts, the history. More recently there's been work in practice-based research, or sort of a constructive research. I struggle with that, because clearly that's the kind of work that I do. I'm very much in support of that, but I also have seen a tremendous amount of work that wouldn't pass as bad practice sort of wrapped up as research and submitted. I think there's a big problem in the arts right now, if we're going to call this research, that there are no measures for rigor or relevance or quality. I think that is a huge concern of mine, because it can so easily turn in the wrong direction. I feel like doors are just opening, and if we don't set some standards for ourselves of what we mean by quality and rigor, then other people will set them for us. We will be very unhappy with those standards. I work with a ton of collaborators in Europe where the Bologna Process has pretty much forced everyone who was a practitioner teaching at universities to become a researcher. I think practice-based research there, and also in places like Australia, has been sort of just a label to re-label practitioners as researchers. I think that's wrong. I think

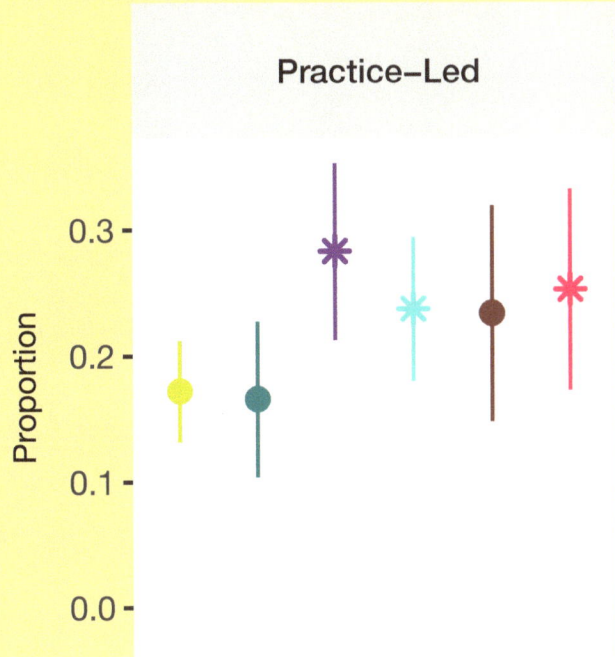

Above: Topic prevalence by discipline clusters for the topic "Practice-Led." Respondents whose self-reported primary disciplines were the Humanities, Music, and Social Sciences clusters included this topic in their definition of arts research in somewhat higher proportions.

practice is wonderful. We're training students to go out and practice. If we lose our connection to practice, we sort of lose our soul in the arts. I would love to see a tenure process that supports people that are wonderful practitioners, people that are doing the study style of research, and people doing constructive arts and design research. I think it's a big enough place."

"Arts research, I would say it's the discovery of new methods, of new tools, of perhaps new purpose or art."

"Sometimes it's finding out new materials, sometimes it's finding out new technology, sometimes it's finding out new cultural ideas. And it's the synthesis of all of those things that come together to form something that you can say, hey, look at this; I've come up with a painting, a sculpture, a piece of music, an expressive dance, a new garment or whatever. It's a new thing."

Practice-based and practice-led are not specifically differentiated in this topic summary. However, the reader should be aware that these and other distinctions have been made. See for example, Niedderer, K., and Roworth-Stokes, S. (2007). The role and use of creative practice in research and its contribution to knowledge. IASDR International Conference.

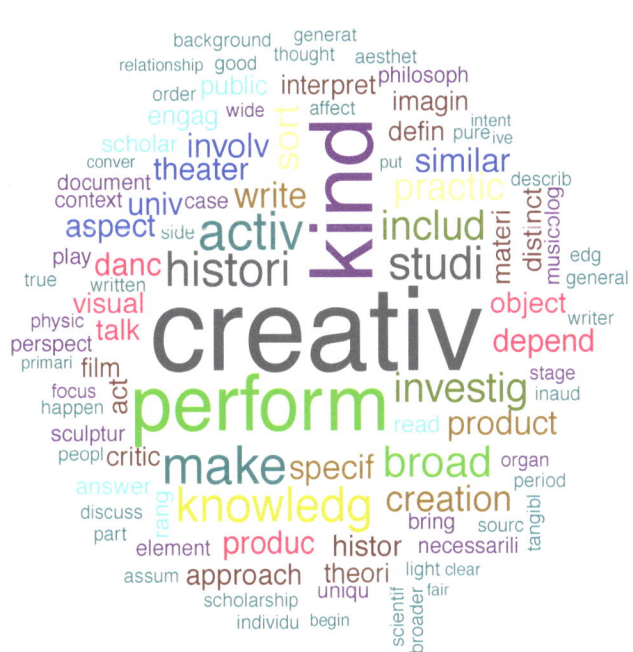

Above: A word cloud for the topic "Practice-Led" with words weighted by their probability. Larger words represent higher probability words for the topic, and color contrasts help distinguish probability levels.

ARTS RESEARCH:
Creating and Disseminating New Culture

FROM MARVEL TO MYTHOS

> "Arts research is researching and discovering new forms of expression or perception that relate to an aesthetic experience."
>
> **PROFESSOR**
> **PSYCHOLOGY**

> "Arts research, as I understand it, is … At least as I'm attempting to practice it, is the development of language where language doesn't exist. On the wave front of cultural, social paradigm, and if you're really good, you've moved the paradigm. If you're exceptional, you are on the front side of the paradigm moving out into territory that is yet to be defined."
>
> **ASSOCIATE PROFESSOR**
>
> **SCULPTURE**

DOMESTICATION OF THE DINOSAUR

Above: Domestication of the Dinosaur, an exhibit at the Center for PostNatural History (CPNH). CPNH, led by Curator of PostNatural Organisms and Carnegie Mellon University Associate Professor Richard Pell, acquires, interprets, and provides access to a collection of living, preserved, and documented organisms of postnatural origin. Photo credit: The Center for Post-Natural History.

Arts research invents, creates, engages, critiques, aestheticizes, languages, practices, expresses, and communicates. Arts research is about adapting to constantly changing cultural reference points, training and retraining people's attention, aesthetic preferences, and judgments in an ever-shifting social, technological, material, and political world.

"I would say it's inventing new culture that can be judged by one's degree of influence in terms of shaping new questions that are asked, broadly shaping what kinds of work is made in the world. One can measure its influence by thinking about the extent to which it's cited, quoted, mashed-up, chopped up, reinterpreted, covered, linked to, blogged, and so forth. What is arts research? It's about inventing new kinds of experience and about presenting new kinds of experience for people to question how they understand themselves, how they see the world, and it's about research into systems that are perhaps expressive, not functional."

"The first thing that comes to mind, for me, is engagement. And I think about engagement and critique. Because I think that, in conversation, an example for me as a painter is I think that knowledge of art history is crucial. And there are a lot of other painters, I think -- there are painters I know who don't really know anything about art history; they don't care so much. I mean, they might like other painters or certain paintings, but then the desire to know about what has come before is not necessarily there. I think it's crucial because the conversations that I'm having with a canvas are only happening because painters have come before who've done certain things, even if I'm aware of them or not. So there's that kind of conversation. And art is also critique and engagement with the world or something you see and

you're responding to. I'm a figurative painter, between figurative and expressionist. I'm not a realist painter. So I'm more into what is the world, when I look at the world. And I would say if I'm painting trees or something, just as an example, I don't want to paint how I think the trees look, but what is it that I could paint or express about the trees that then again might become a conversation where people start to see trees differently. And in my own pathway, there was a period of time where I was painting a lot of trees. And I realized after a certain period of time that -- I think I was driving one day and I was looking around; I realized I was starting to see the world differently because of the way that I'd been painting, and I was starting to see trees differently because of the way that I'd been painting. So there again, art is this real, it's this active, constant, continual engagement and, of course, expression, expression of beauty would be an obvious one, but more than that—expression of emotion and circumstance."

"… So when you see something and it pulls on you to respond in a certain way and to replicate it, whether it be in the same form, so you see a painting and you want to respond with a painting, or even you want to tell somebody about the painting, or you want to write a response to the painting. And it also opens up the definition of beauty to be things that you don't consider visually beautiful. It could be what we consider ugly or grotesque that calls for a response. Or it could be taking it to a social situation, something that's going on socially, a problem, a question you could either think about that calls for a response; and so that's a back and forth. So arts research, that's one way, you know, the question of beauty, that traditional question. Also, I think about how do the arts motivate people to change and shift the way they live or experience? … So that would be a place of arts research, is how do the arts make us see the world differently? How can you use the arts to make somebody see something differently?"

"Well, art research; I was thinking about that question, so arts research is related to the process of producing art. So we can think about for example, nowadays we have a lot different technologies and we can think about how we can incorporate technology in arts or we can go back to history and say, let's understand the history of the arts in regards to this specific time or with regards to this specific art. And also, how people interact with art."

"It is studying and accounting for the historical trends and philosophical and political dimensions of practices that are often called art. So it is already what humanists already do. I think that it's also increasingly a way of thinking about a certain way of positioning artistic practice so that the execution of an artistic form or artistic event becomes itself a central method of pursuing a question. Whether posing answers to it or provoking new reflections. Sometimes, that shows up in some historical forms as equivalent to what conceptual artists do. Arguably, when I led at one point a strategic working group at our humanity center for a year on a question; when is art research? That was the central question. One of the first answers that came back from arts historians in particular, is that art research is a way of delineating how art changed when artists became less and less concerned with the formal execution and virtuosic execution of a form and more interested in an idea. And that the idea of the art form was itself the central preoccupation."

"My personal understanding of that is the arts research again is, primarily, anything that moves the discipline forward. I think something that I'm involved in that's very interesting to me is to engage in a practice that sort of attempts to understand what arts practice is. The early part of the 21st century, particularly given the fact that society has changed, the way we communicate has changed. The tools that artists want to use, those are changing. In the midst of all of this change I think, our understanding of what it means to be an artist is changing and I'm pretty fascinated by those kinds of questions."

"That is more the aesthetic and ideas component of that research. For me, that involves exploring new ideas that arise as cultural ideas shift and change, and that arts need to sort of reflect and explore our changing world, not just technologically changing, but socially changing as well."

"The exploration into the meaning of visual culture, and how it's been constructed both physically and socially."

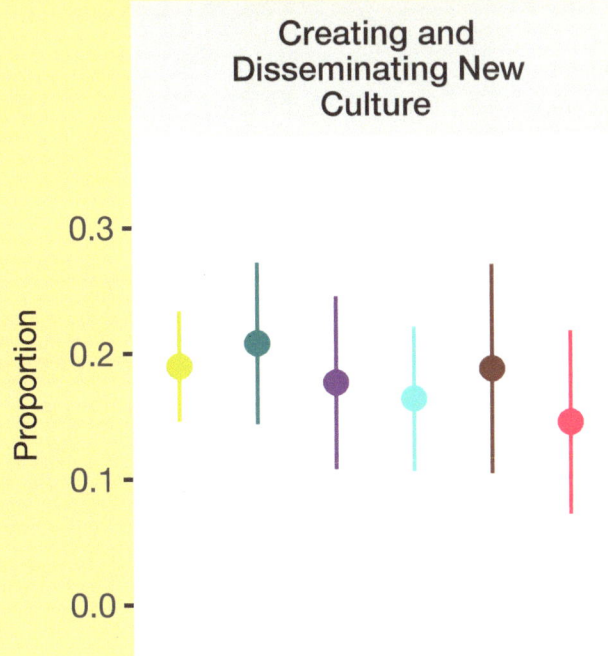

Above: Topic prevalence by discipline clusters for the topic "Creating and Disseminating New Culture." This topic was the second-most prevalent among respondents after "Practice-Led," and the two topics are conceptually related. Together these two topics account for about 43 percent of respondents' descriptions of the definition of arts research. Notably, there are no substantial differences among disciplinary clusters around this topic.

"I think of it, in our community here, as exploration. There is scholarship. There is a little bit of traditional research, but a lot of it is looking at either influencing culture or creating new culture, as opposed to either creating new knowledge or expanding existing knowledge."

"Well people don't think that artists research, but this is actually incorrect. We have a long history at [our university] of artists investigating a number of things: from spatial organization, film and video techniques, and aesthetic properties of things. Today's artist deals a lot with the history of culture and how to represent it, untold stories, which require kind of archival research and then ways of representing this through the mode of exhibitions or filmmaking or video. So, you know, I think all of the artists who've ever taught here have been serious researchers."

"I think for me, research in the arts would really be about tapping the creative potential of the artist, of the researcher to extend human knowledge or human culture."

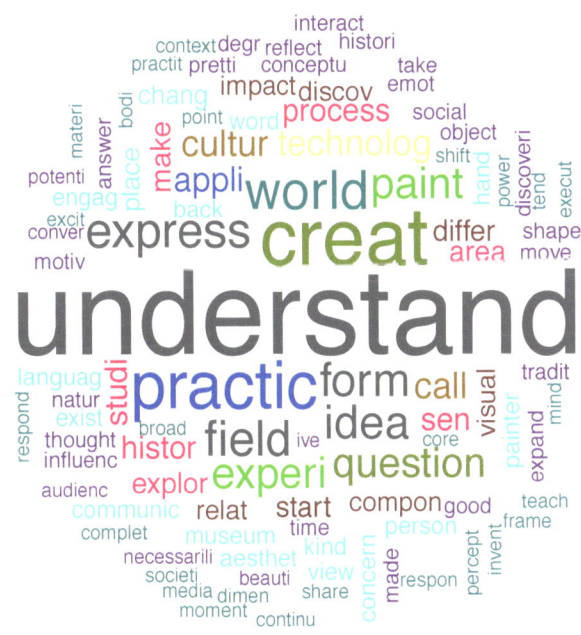

Above: A word cloud for the topic "Creating New Culture" with words weighted by their probability. Larger words represent higher probability words for the topic, and color contrasts help distinguish probability levels.

ARTS RESEARCH:
Human-Centered

FROM THE SELF TO THE SUBLIME

> "It's more of a turning inward exploration. Arts research is not dependent on the phenomena of the world around us. That could be part of it, but more the research is in how we see the world around us, and how we explore that."

VICE PROVOST AND PROFESSOR
BIOLOGY

> "To me that means the self-conscious thinking about ways in which they are developing themselves as artists, as creative people, ways in which they're pushing at new boundaries, and this is very variable. For some people that might mean expanding the medium in which they work, for some people that might mean interdisciplinary explorations, for some people that might mean new modes of determination."

ASSOCIATE VICE CHANCELLOR FOR RESEARCH AND PROFESSOR
ANTHROPOLOGY

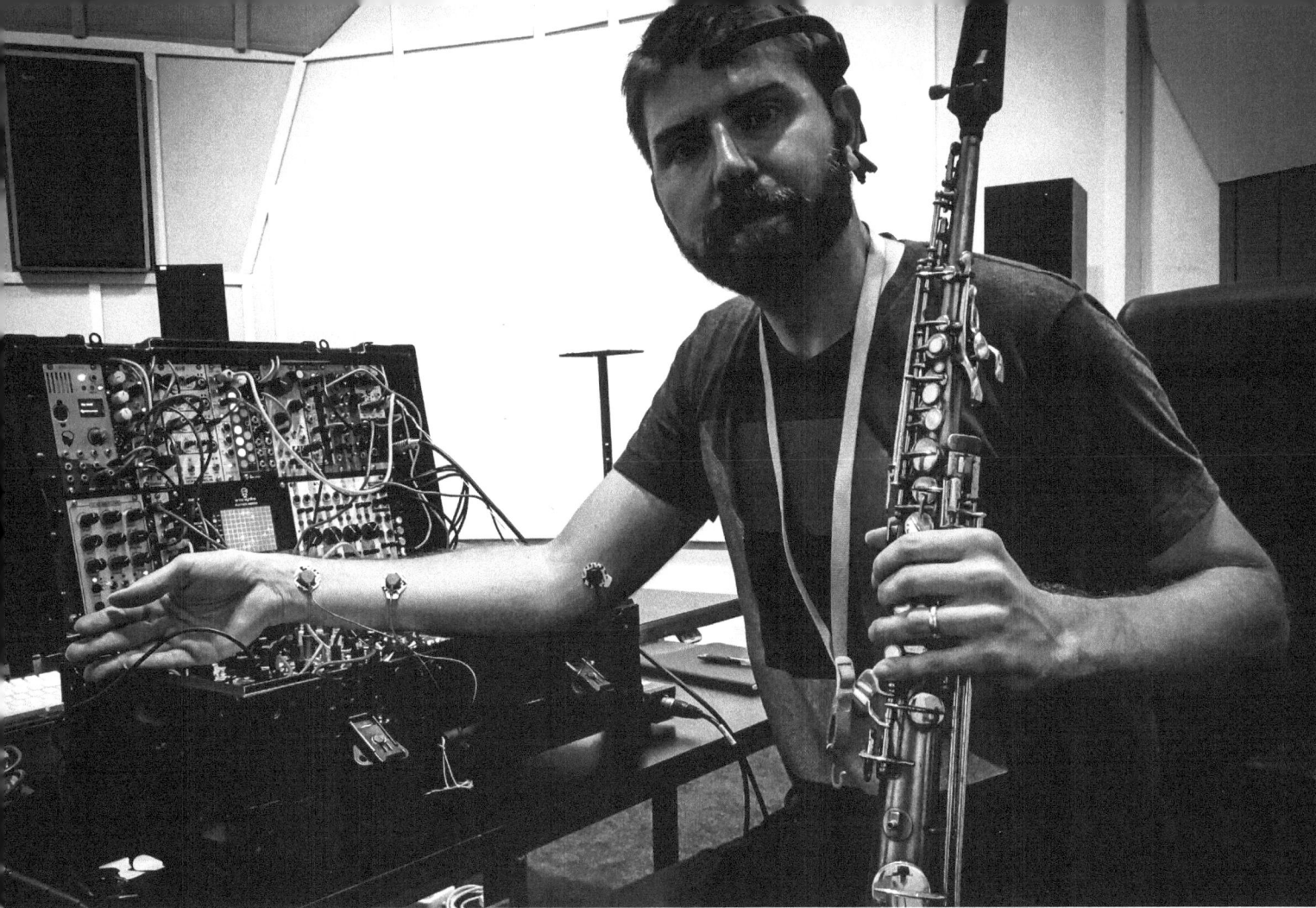

Above: University of Alabama Associate Professor, composer, soprano saxophonist, ethnomusicologist, educator, and arts organizer Andrew Raffo Dewar performs *Anabolism* (2015-16), his composition of electroacoustic biofeedback music for modular synthesizer-based live electronics and soprano saxophone. The piece translates the performer's sound and aspects of their biological functions (brainwaves and muscle movements) into control signals that affect the live electronics, such that the form of the music itself is partially generated and manipulated through biofeedback processes largely outside the performer's control.

Arts research is a human-centered endeavor, dependent on the subjective exploration and expression of an artist or scholar, translated and disseminated to a necessary audience through the studied manipulation of media and technique.

It is at its core, self-conscious, with the arts researcher as an individual looking inward to process and engage with the research question, develop and employ their individual skills and insights, and then create an outward-facing manifestation as the answer — that is, the creative output of the arts.

In the attempt to discover answers to questions of the human condition, arts research illuminates, uncovers, and deepens understanding. But, in doing so, it leaves the initial question ultimately unanswered, or reframed, or with an "answer" that leads to more questions. It is this ultimate open-endedness that allows the research question to be endlessly re-explored through the subjective lens, leading to discovery and rediscovery, changes in technique and media, and ultimately the evolution of our understanding of what it means to be human.

"I think arts research differs from other research. Particularly in my discipline because in the work I do as a dancer and choreographer, I'm always investigating the human condition."

"I really look at arts research as more of a creative approach to research. I look at the way artists deal with ambiguity and deal with the unknown. I think their approach is a lot more rigorous. I think they challenge the questions a lot more. I feel like maybe there's even a more personal approach to answering those questions."

"It would include the critical study of the arts, asking other kinds of questions such as 'what is the significance of this artistic activity as a form of human expression? Arts researchers can seek answers to so many different questions about art (and artists): how and why it is done, its significance, how it changes over time' – all of these are legitimate questions to ask, and the pursuit of such answers is arts research."

"I think that's a very complicated thing. Because one of my chief concerns in my head, approaching a lot of things through the lens of literature and creating art myself, is that I realize that, for example, as an African American writer, I think of myself as writing in the vanishing language of an illiterate people. Because I write from the perspective; I was born in Detroit in 1959 in a place I call Detroit, Alabama. And most of my grandparents could not read or write, and so their stories were not put down. And so arts research, to me, includes, since my understanding of the arts is a little bit more fluid and caustic than some, is trying to document, understand, make sense of, the various creative ways that people have ordered and made sense of their existence. So that can include, for me, looking at a couplet or a nursery rhyme from the streets of Detroit—*"They said the best was Sugar Ray. That's before they all saw Clay."* And that might begin by finding out how commonly was this couplet known, what other cities was it known. So, to me, arts research can -- but it also includes looking at paintings, it includes all kinds of things. But it includes trying to document people's imaginary lives and the ways they restructure objective experience to sustain themselves, document themselves, tell their stories."

"I understand arts research as the sort of self-conscious development of the capacities of someone who works in a medium other than text. To me that means the self-conscious thinking about ways in which they are developing themselves as artists, as creative people, ways in which they're pushing at new boundaries, and this is very variable. For some people that might mean expanding the medium in which they work, for some people that might mean interdisciplinary explorations, for some people that might mean new modes of determination."

"It's always been very hard for me to grasp art research, simply because traditionally art faculty have focused on techniques and improving techniques. I'd like to think that research in the arts ... I'm at a loss for words, because for me as a biologist that comes from a very strict idea of what research is as a scientific method. It's not the same for the art ... It's more of a turning inward exploration. Art research is not dependent on the phenomena of the world around us. That could be part of it, but more the research is in how we see the world around us, and how we explore that. It could be part of, "How do I work with the medium that I have in order to reveal something." For me the research in part with art is a little bit abstract but definitely has methodologies attached to it. I like the fact that, when artists are in collaboration with scientists they get a chance to see the more definitive side of that, but through their art. For me, I've always struggled with the right words, and having this position gives me the opportunity to explore it even more, because there is a depth to research and art that you do not find in the hard sciences. With the hard sciences, it's the more I can distance myself the better quality the research. With the artist it's more that I can move into the phenomena allows for a better sense of the research. It's more of who you are as a human being and how you approach it with the artist being more reflective and being more involved with the medium and the hard scientist being more objective and removing themselves from the medium."

"[Arts research is] really the same [as research]. That we have a set of disciplines—those disciplines have developed over years to a certain rigor and definition and that research is to go deeper, to search again, to either make it go deeper or richer, or to expand those definitions of what those disciplines are in the process of that creating something new or writing something that will expand our own notions of it."

"In terms of the studio artist, I would guess that it would be exploring their medium, maybe going beyond their medium, trying various ways to get their point across."

"I think the arts and sciences are so interconnected and artists are also seeking those answers which in turn lead to greater questions."

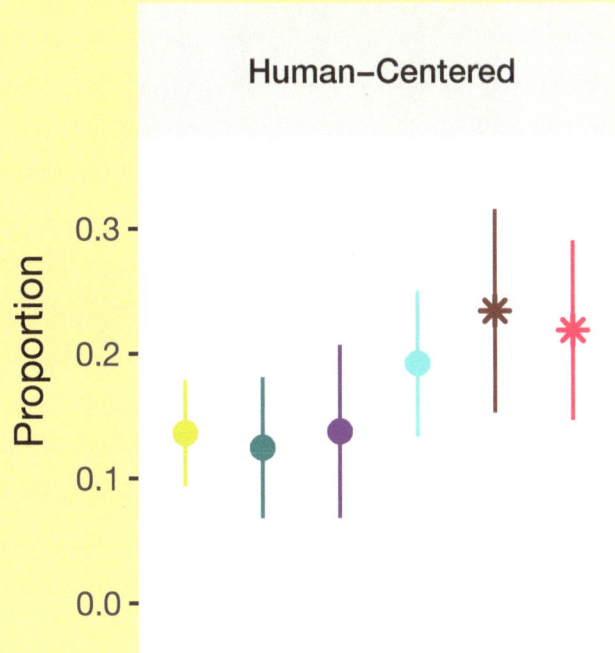

Above: Topic prevalence by discipline clusters for the topic "Human-Centered." Respondents in the Natural Sciences and Medicine and the Social Sciences disciplinary clusters described this topic in a higher proportion compared to other discipline clusters.

"Arts research can be interesting because it can be arts research as technique and practice, into methodologies, new forms, new functionalities within which we create new art forms and processes – whether that be any form of automated machine, to the computation today, to the crowd and the network. I think arts research can also be the way in to begin thinking about a research problem and framing. But if you go back to the question of arts integration, if it should be this idea of the understanding of the human and the elevation of the human experience as the core of the research problem, then arts research can be found in any field, in may ways. We might have to think a little more broadly in scope for some of the so-called harder sciences, but it's that sense of art research fundamentally beginning with the human and the betterment of the human condition in a transformative way."

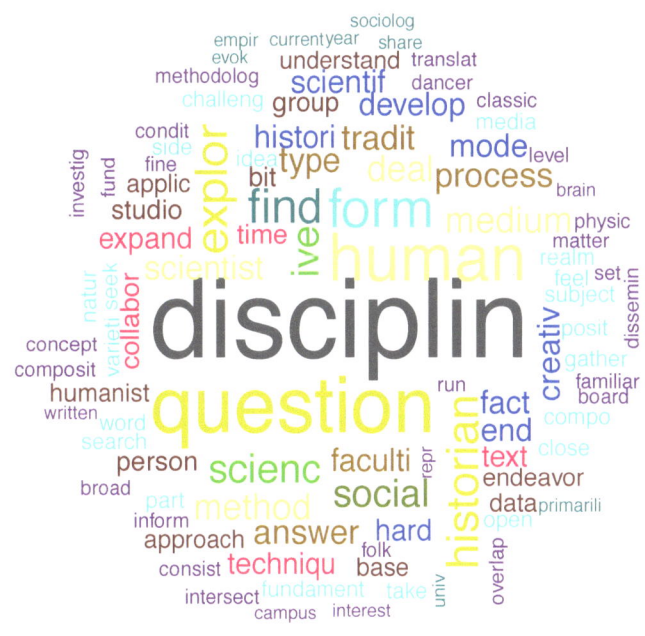

Above: A word cloud for the topic "Human-Centered" with words weighted by their probability. Larger words represent higher probability words for the topic, and color contrasts help distinguish probability levels.

ARTS RESEARCH:
Engagement

FROM AGENCY TO ACTION

" "I see design research as a vehicle to bring the community inside the walls of the institution, the institution inside the homes of the community. I see this as a sort of porous membrane if it's to be effective."

ASSOCIATE PROFESSOR AND CHAIR
GRAPHIC DESIGN

" The artistic sphere is a very special place we've created in human culture—where hypotheticals, where not necessarily physically real, where potentials, where pasts, where aspects of the present that aren't easily visualized—where all of this can be played out, can be modeled, can be displayed, can be explored."

PROFESSOR
ART HISTORY

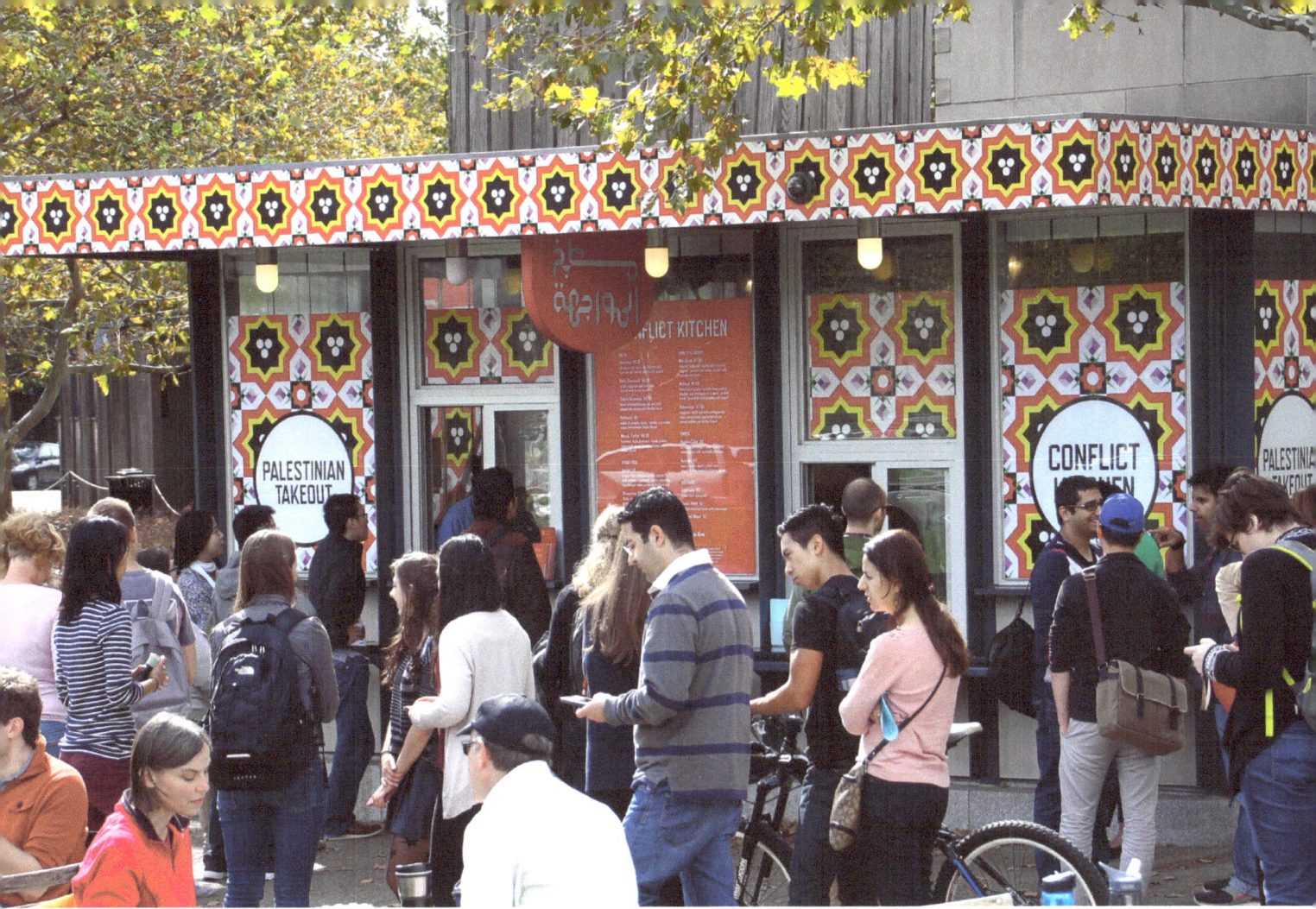

Above: Conflict Kitchen is a take-out style restaurant that serves cuisine from countries with which the United States is in conflict. The restaurant rotates identities in relation to current geopolitical events. Food is served out of a storefront in the middle of the city, and each Conflict Kitchen iteration is augmented by events, performances, publications, and discussions that seek to expand the engagement the public has with the culture, politics, and issues at stake within the focus region. Conflict Kitchen is co-founded by Jon Rubin and Dawn Weleski, STUDIO fellows at the Frank-Ratchye STUDIO for Creative Inquiry at Carnegie Mellon University.

Arts research as engagement connects and galvanizes its audiences. It often seeks to meet people where they are, but it also surprises, provokes, informs, and inspires reflection and critique in unconventional ways. And while critique is sometimes the starting point, the end result is community—more often than not.

One interviewee describes the role that engagement plays in collaborating and coordinating with others towards the realization of community goals and outcomes, as well as what it means for teaching and learning:

"In my own practice and again in my teaching because I actually teach environmental sculpture on an advanced level and on a lower level I teach eco art which is like a version for younger less educated people, but we have these classes you can take that have been part of the curriculum since 1993 when we formed a new and more progressive curriculum. It was called art in context where we teach this practice where we send students out to do community-based projects. Recently we've changed it. It's more a progressive term: contextual practice, so you're doing art out in the world, engaging with social issues and with people. A lot of avenues of research there.

One is: I go out myself. Currently engaged working with a well-known artist Betsy Damon in a marginalized neighborhood Lairmer, which is just about a mile from here—where revitalization is marching along. This neighborhood's going to be next. They've prepared it by taking down sixty percent of the houses. It was an awful neighborhood. The buildings aren't very good. Pittsburgh, like most

Above: The Nine Mile Run Watershed Association grew out of the Nine Mile Run Greenway Project, run by the STUDIO for Creative Inquiry at Carnegie Mellon University in Pittsburgh, PA. Through a series of community dialogues, workshops, on-site tours, publications, and exhibitions, the team affected a change in the community's understanding of the synergy among environmental, economic and artistic issues. The Nine Mile Run Greenway Project facilitated a complex series of events, which catalyzed and contributed to the environmental stewardship of this area; this led to the formation of the Nine Mile Run Watershed Association, then to the ecological restoration of the stream, plus the greenway extension/connection between Frick Park and the Monongahela River.

urban places, is built very densely and like now all of a sudden has opened up all this green space.

Betsy Damon, who's all about water, I'm more of a land-based person. She's a water-based person; having an exhibit at the Mattress Factory and I was linked to her because I've been here for years and know the water people through that Nine Mile Run project. One thing came to another. She didn't want to just do an installation in a gallery. She wanted to do something real in the world. That's really her practice. I lined her up with different people and helped her find a site where she could do a project about water. Now we're engaged in what's called the Living Waters of Lairmer. We're researching the history, trying to get green infrastructure in the ground; every drop of water that falls on the neighborhood to go into the ground naturally, infiltrate into the ground instead of going down the pipes, which was a huge problem here in Pittsburgh of combined sewer overflows whenever there's a storm event.

To give you an example there, what really peaked our interest, it was an extremely helpful tool we linked to. This man, Matt Graham, who has a company called LandBased System, where for twenty years he's developed his own software for the whole county to help take care of this water/sewer storm water runoff problem. He's got software to map and he can go in any area we ask in this neighborhood, draw a square on a block, and it shows where the water goes down the drain and how much water goes down the drain depending on how hard it's raining, which makes it much easier for us. A cool tool to

intervene and figure out how to build rain gardens, bio swayls, or store water in cisterns to be used later. And, just as technology, it's this great software. Part of the research is I as an artist, again, I'm driving the conversation. I don't have all these expert tools. Sometimes I got to people on campus. In this case there wasn't anybody, but this is a professional in the world. I've done it before with soil scientists on the Nine Mile Run project, trying to get things to grow in the slag heap, which isn't a good growing environment—what to amend the soil with in different natural processes which took me to green roofs with my class. [...] They wanted to do it as a research project. You get small, undergraduate research grants here. They need an advisor. It wasn't working out with their architecture professor. They heard about me. We drove a four-year project. Slow but sure, and that was through facilities management services, the university engineer, and a couple of environmental engineers who are on the green practices committee and located a 4,000 square foot roof, raised some grant money; the university would put a new roof on it, but couldn't pay for the green component. I brought an expert in green roofing from Stuttgart, Germany who came to my class. I also then just committed to teaching a class in it, even though I'm no expert, but I brought in an expert to help and a few other local people and learn about how to do it. All the reasons for doing it are huge for the students who are involved in it and actually did the first green roof on campus."

• •

Another interviewee, an art historian, articulates a perspective about arts research that draws on her knowledge of the domain and field of visual arts and critical theory:

"I believe the paradigm of artistic research essentially grew historically out of the moment of institutional critique. When artists proved to be the most savvy at understanding and representing the way power structures determined our representations. I've done a lot of work on Hans Haacke, for example. He's often considered a certain pioneer of this moment. When he does Shapolsky et al. Or when he does his project on the Guggenheim board of trustees. There's actually just shoe leather research in this game. He has to pad around to the Department of Buildings. He has to research the landlords in Manhattan. He has to make file cards and index cards that he carefully types out with all their interlocking directorates. He maps these graphically and photographically. He locates them on maps. This is very pedestrian kind of research. This is what you would expect a very bright high school student to be able to do for their term paper on New York landlords. I think what then came to be possible in post-modernism and the theorizing of post-modernism was the artist was uniquely positioned to interweave fact and a certain kind of productive fiction. We have Paul Auster in literature. Haacke couldn't go there. Haacke isn't a post-modernist. But someone like Walid Raad, who taught right alongside him at Cooper Union, that is a legacy of institutional critique that brings fiction into the game. Walid Raad, who forms the Atlas Group will give an artist talk and what the audience doesn't always know is in the audience is planted a question. After the talk, this planted questioner says, 'How can you make up this art? None of these things are real. How can you pretend they're real? What about the real people who died in Lebanon during the wars?' Then Raad gives his prepared answer. 'If I had not given you this fiction, would you care about that fact?'

The artistic sphere is a very special place we've created in human culture where hypothetical, where not necessarily physically real, where potentials, where pasts, where aspects of the present that aren't easily visualized; all of this can be played out, can be modeled, can be displayed, can be explored.

Since I'm an art historian, I love this fact. I love this idea. I don't know how that works in music. It's too abstract for me to get a handle on and I'm not a musicologist. However, I can easily see in theatre, in dance, in the visual arts, these are places where models of realities, alternative realities, subaltern realities, post-colonial realities, hypothetical future progressive realities, dystopian realities, these are all out there for us to imagine. That, I think, is extremely powerful. Artistic research in a nutshell would be all the investigations into our present that fold in the potentials that have become realized from the past; or lost futures that we've neglected in the past. Or futures we can only imagine."

Finally, we asked Dr. Mark Ballora to help us interpret this topic of engagement within the domain of arts research. Dr. Ballora holds a joint appointment in the School of Music and the School of Theatre at Penn State University, where he teaches courses in music technology, history of electroacoustic music, musical acoustics, and software programming for musicians. His work includes sound designs, data sonification, and electroacoustic scores for modern dance, theatre, museums, festivals, animated films, civic events, and radio dramas. The following is his synthesis of the interview responses on the topic of engagement.

"Arts research is a form of engagement, bringing out commonalities that we may not even be aware of, giving us knowledge of things in new forms that cannot be expressed verbally or numerically. This knowledge was, I felt, well described in the New York Times by David Brooks in a column titled 'How Artists Change the World':

> '…[A]rtists make their mark… by implanting pictures in the underwater processing that is upstream from conscious cognition. Those pictures assign weights and values to what the eyes take in…I never understand why artists want to get involved in partisanship and legislation. The real power lies in the ability to recode the mental maps people project into the world.' https://www.nytimes.com/2016/08/02/opinion/how-artists-change-the-world.html?

Which is not to say that all artistic creation is research. When someone prepares a performance of a piece from the established musical canon, it is not necessarily research, any more than an undergraduate essay on Jane Eyre is original research. So the fact that a university music professor may put a great deal of time into the preparation of a performance does not by definition equal research. Another distinction raised by some interviewees is between practitioners and researchers. A practitioner is not necessarily a researcher.

One interviewee brought up another distinction that is important to keep in mind between scientific research and arts research: "Scientific experiments… have to be reproducible and have to be gathered with some metric." While many musical pieces may be reproducible in the sense that they have been performed for hundreds of years, in most cases the creation of art is meant to be the creation of something that is unique and not reproducible. Even when someone performs a well-known piece of music, the idea is usually to perform it differently than others have.

The other part of this comment is the idea of a metric by which experiments are gathered. The metric for artistic 'experiments' is a completely different form of evaluation than that which applies to scientific experiments. This is because the 'new knowledge' that art creates is an entirely different form of knowledge than that which is provided by the sciences. Other interviewees described the arts as a 'symbolic understanding of reality' that 'investigate the human condition.' This describes an entirely different form of knowledge than that which is gained by the traditional scientists.

How does artistic knowledge investigate a subject area, how does it motivate people to change and shift the way they live or experience, how does it present new kinds of experience for people to question how they understand themselves? An example that came to my mind as I read the interviews was from a television situation comedy in the 1970s. Most sitcoms are not considered high art – they are meant for pure entertainment, created with a certain craft and set of skills, but hardly intended to cause people to question and understand themselves. But sometimes a workman-like craft can transcend its milieu and achieve something more revolutionary. Many comedians are regarded as important forces in social change. The television comedy *All in the Family* is widely regarded as broadening awareness of societal prejudices and bigotry. The program took these qualities from being a tacit and silent understanding to becoming open and preposterous notions when voiced by the character of Archie Bunker. I always recall one scene where the African-American neighbor is at the Bunker household. Frustrated by something Archie says, he exclaims, 'Why do you people always do this?' Outraged, the white man replies to the black man: 'Who are you calling "you people"? You people

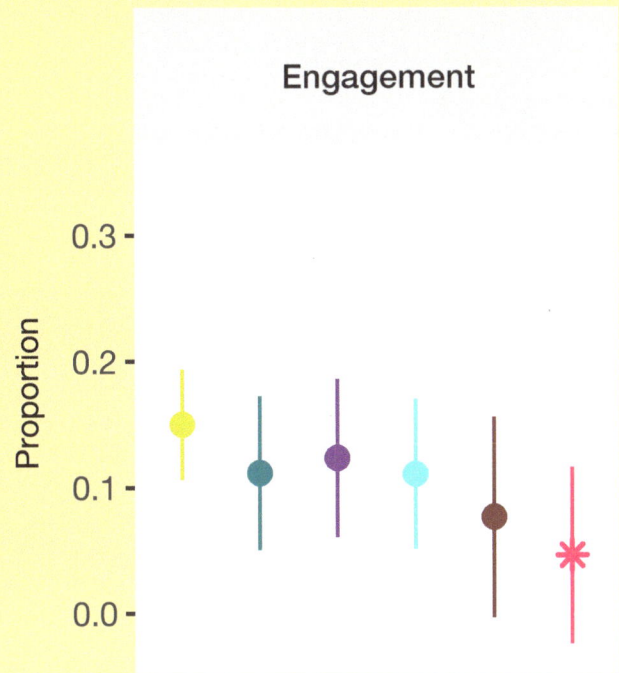

Above: Topic prevalence by discipline clusters for the topic "Engagement." Compared to others, responses in the Social Sciences cluster were less likely to describe Engagement in their definitions of arts research.

are "you people"!' I find the irony of this line to be ingenious. I don't know when eleven words have said so much about the nature of race relations. This was comedy, meant for the masses, causing a shift in the way that people experienced their lives.

Not all art is as straightforward as this example, which involves verbal content. Many of the arts are symbolic, and affect us in very different ways than are achievable with numbers or words. Architects describe the human experience of space. One interviewee states that 'Architecture is one of the oldest forms of communication that we have,' but I have to take some issue with that. Writers such as Steven Mithen, author of *The Singing Neanderthals*, describe music as a pre-linguistic form of communication that was essential to the survival of our species. It provided rapid communication as well as cohesive group bonding experiences that leveraged the social nature of humanity. Works such as Beethoven's *Fifth* or *Ninth Symphonies*, or Samuel Barber's *Adagio for Strings* affect people at extremely deep emotional levels, giving voice to experiences that supercede any individual's experience, and manifest universal facets of being human. It is difficult, if not impossible, to quantify or provide metrics to the effectiveness of these works, yet they are obvious to listeners. It is difficult not to appreciate these pieces as research, as they undeniably represent a translation of knowledge from a realm that is intangible to one that is tangible."

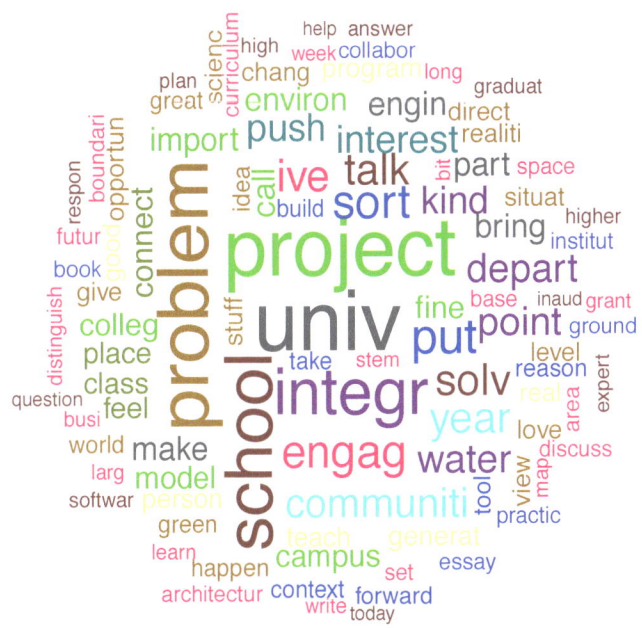

Above: A word cloud for the topic "Engagement" with words weighted by their probability. Larger words represent higher probability words for the topic, and color contrasts help distinguish probability levels.

ARTS RESEARCH:

Humanistic Scholarship and Social Scientific Research About the Arts

FROM COGNITION TO COSMOS

> "It's about pushing myself to the boundaries of my limitations as a maker and a thinker. So if I'm working on a project I'm not only making things but I'm also reading things about it if I can, or looking at things that relate to it from other disciplines, or the combination of all those activities."

PROFESSOR
DEPARTMENT OF VISUAL ART

> "Arts research can mean different things to different people. For me, it is both a scholarly and a creative practical approach, or arts research involves both creating art in a production environment as well as studying the practical implications or understanding the art more."

ASSISTANT PROFESSOR
THEATRE AND DRAMA

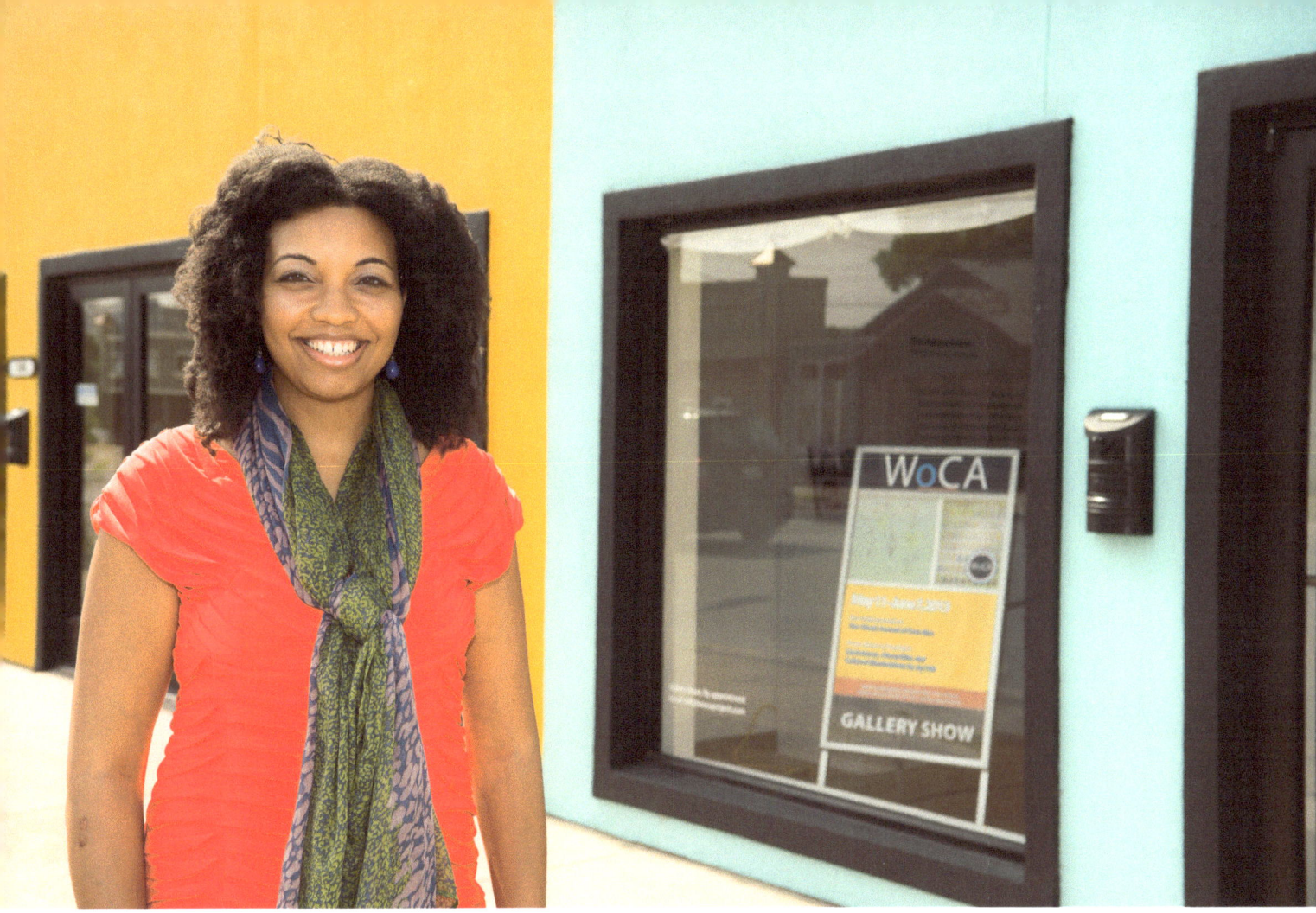

Dr. Lauren Cross, Lecturer for the Department of Art Education Art History's Interdisciplinary Art and Design Studies (IADS) program at the University of North Texas and Founder and Chief Curator of WoCA Projects, a non-profit artspace in Fort Worth, Texas, examines the implications of and strategies for curating exhibitions that feature the works of women of color artists. Dr. Cross conducted visitor studies to identify the institution's diverse "observing communities" and to understand nuanced visitor experiences with exhibitions, as well as open-ended interviews with curators of cultural spaces about their curatorial strategies, and how they see their exhibitions impact visitors. Photo credit: Shannon Drawe.

Arts research is scholarship and research about and through the arts. The arts, its history, modes of engagement, practices, and arts education constitute objects of study, domains of scholarship, and areas of research in the traditions of the humanities, social sciences, and natural sciences.

"Art research I think goes to learning about a specific environment, a specific place or a specific society. You want to fill the gaps of something. That's what I feel when you want to do research. It could be an education, it could be learning about what's really happening, how the developing of the art is happening. Something that has not been done before."

"So arts research has several dimensions. It can be the kind of sociological research that the Curb Center has done a great deal of, that looks into what kind of careers artists have, that looks into how artists make lives in this world, that investigates the kind of impact that the arts have. It, of course, can be a kind of historical research. So looking at the way some of the problems that artists faced in the 19th century, it can be models or be dramatically different from the problems and opportunities of those contemporary artists. Art historians generally, of course, have a historical perspective on their discipline."

"The process of generating data regarding the processes and results of art-marking for purposes of identifying conceptual and cognitive patterns of meaning, explicit or implicit, intended or unintended, within arts objects or experiences."

"I'd consider arts research to be more arts scholarship. ... There can be research related to the arts in terms of how it is taught, how it is conveyed, how the arts can impact people's lives. For example, we have people here who are using things like music

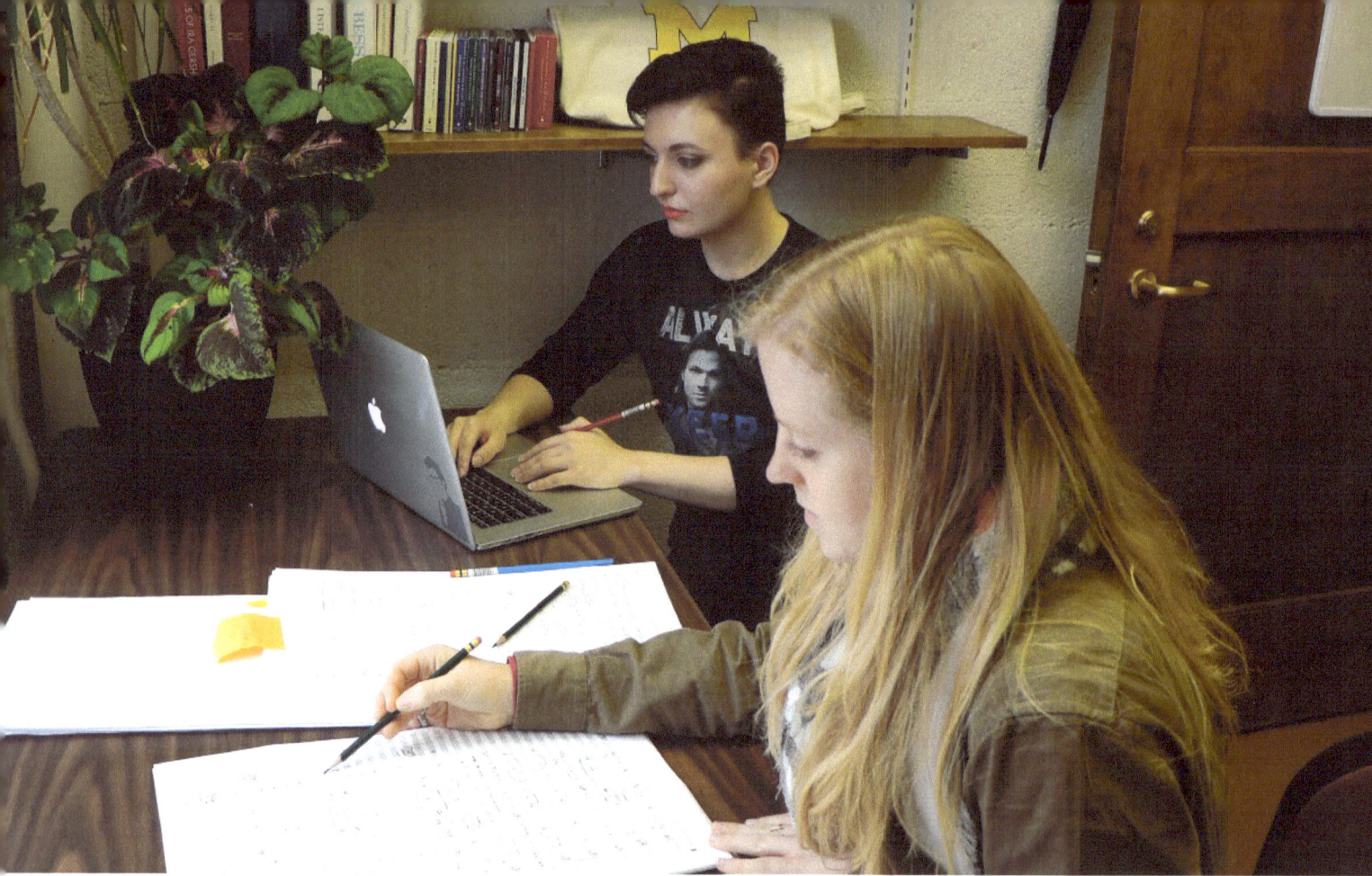

Undergraduate Research Opportunity Program students Sarah Sisk and Frances Sobolak contribute to the University of Michigan Gershwin Initiative, a scholarly examination to document and analyze the music of George and Ira Gershwin. Photo credit: Gershwin Initiative.

therapy to help people get well or help them in the healing process. That can be a very structured form of inquiry to see how exposure to different forms of art can aid in the healing process, for example. You can put a fairly structured mode of inquiry around that. That's different from more expressive modes. For example, developing a composition for the tuba or something like that, which may be a form of a research, but it's not really how I understand it. It's more of an expressive form of scholarly work."

"Arts research, I understand that to be, trying to understand the importance of the arts and how they can impact development and how they can impact someones education."

"We have art history. We have museum studies. We have art education and we also have a studio program. I think in art education, the kind of research is establishing and expanding what's involved in educating art students, both in the lower division and upper divisions, expanding or the quest for new knowledge in that. I think in our art history area it's much more about kind of research specifically into the discipline of art history, both contemporary as well as modern and classic, and again, looking at the kind of expansion or inclusion or adding to the discourse and the knowledge of that. In the studio area, I think it, again, involves a lot of different kinds of practices depending on whether we're talking about a kind of performance artist, whether we're talking about a kind of object maker in there. But, again, I think it's the quest for the expansion that would have to do with relationship to the field itself as well as personal expression. You know how personal expression kind of relates to an individual artist and then how that relates to the greater, again the kind of greater discourse of what happens in our practice."

"Well I think that, with the arts research you can use art in ways to enable other subjects, for example, in a psychology course you can act out something with your students. Use some sort of dramatic dialogue to explain a complicated abnormality, for example. I have a colleague whose daughter did a program on the brain and used rock music to teach them various parts of the brain and they did it themselves. I think there are ways to accomplish using it together with the sciences. My own research is finding materials

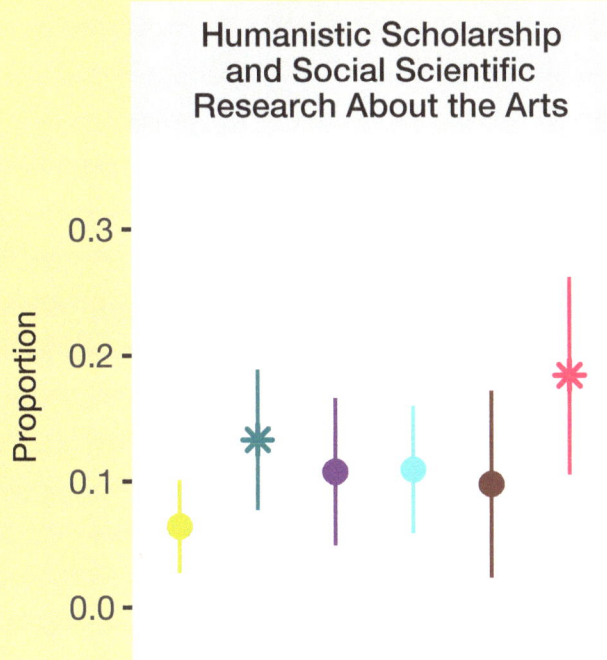

Above: *Topic prevalence by discipline clusters for the topic "Humanistic Scholarship and Social Scientific Research About the Arts." Respondents whose self-reported primary disciplines included the Social Sciences, Education, Business, or Law clusters had the highest proportion of this topic in their responses.*

that maybe haven't been discovered before and figuring out what they are. My own dissertation was a manuscript that had no composure attributions in it. It was from the 15th century. It was sitting in a library in [Bolognia 00:02:52] and I went over there and I had to figure out what all this funny notation meant and who wrote the pieces. There were very few texts in there, so it was detective work. I think that there are whole variety of ways of doing musicological research now. Some don't involve looking at primary materials, but taking existing, even secondary literature and crystallizing it into new ways of thinking about the arts."

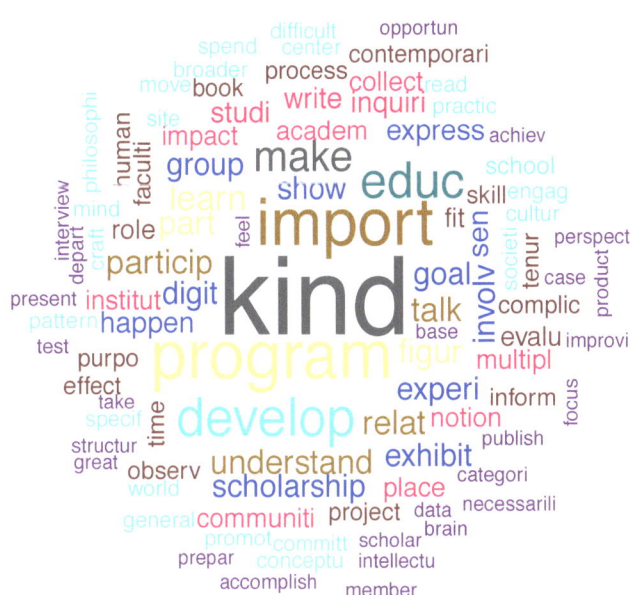

Above: *A word cloud for the topic "Humanistic and Social Scientfic Research About the Arts" with words weighted by their probability. Larger words represent higher probability words for the topic, and color contrasts help distinguish probability levels.*

ARTS RESEARCH:

The Arts and Design in the Context of Academic Research Culture

FROM INSPIRATION TO INSIGHTS

> " I think, in a lot of ways, research is research. Artists do a lot of the same things that scientists do. They do a lot of the same things that mathematicians do. They have a particular area of interest and a particular set of skills and they ask questions about those particular areas of interest and expertise."

EXECUTIVE DIRECTOR
MUSEUMS

> " Within the context of the university when I create an art object it is under the auspices of my position. It is deemed research."

ASSISTANT PROFESSOR
INTERDISCIPLINARY ARTS

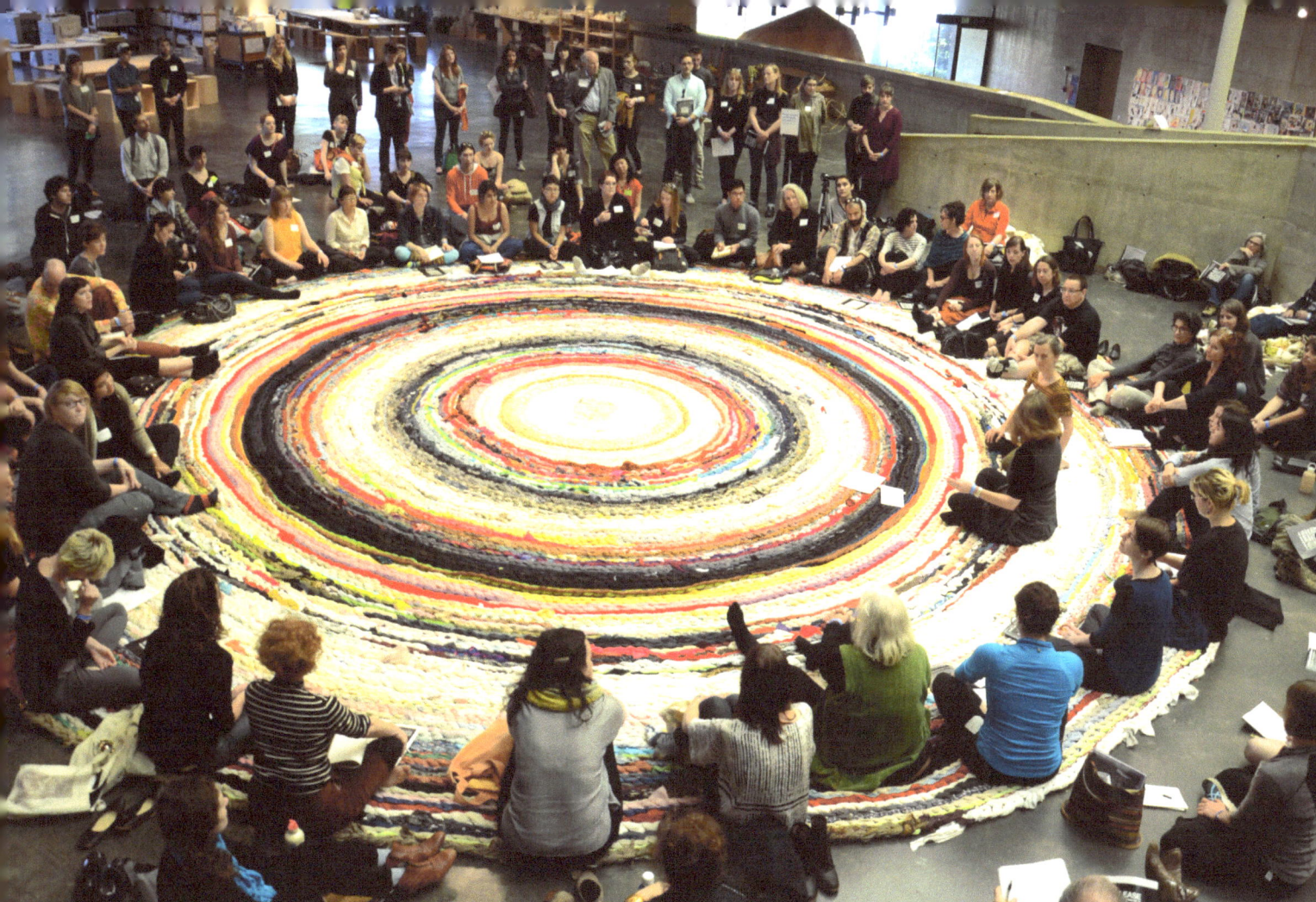

Above: The Arts Research Center's 2014 "Valuing Labor in the Arts" Practicum. Photo credit: The Arts Research Center, UC Berkeley.

For some, arts research is what artists do when they work in research universities. It can range from taking on the mantle of academia, reproducing traditions, conducting public engagement, exhibiting as peer review, performing social criticism, and creating scholarly works. At times, the arts in the institutional context of universities sometimes makes it feel like trying to fit a round hole into a square peg—with stark contrasts among different ways of knowing and modes of knowledge production and diffusion by other means.

"Within the context of the university when I create an art object it is under the auspices of my position. It is deemed research. Well, is it proof of research, or is it in its-self research? I think it could be both. If the act of doing the performance or the act of showing the video is itself, then it would be that perhaps that is the research, the showing the video. The video itself could also be evidence of some prior research where that is the output that the resulting form of that research or the embodiment. Then it would be, is my research output an article? Is that a video? Could be either one."

"Arts research is a way where that understanding may not necessarily be through a written paper, and it's not necessarily a quantitative idea. It can be presenting that research through more of an emotion, or a feeling, or more qualitative."

"Artistic production and artistic practice, what I'm now considering artistic practice is artistic production now. Being peer reviewed, your artistic production peer reviewed. That was very critical, although we can show at other institutions, and I think it's important there be a showing at places that the community goes. With things, especially as you're going up for tenure, it's being peer reviewed at academically recognized institutions."

"Well, I think arts research can take a couple of different forms. The process of understanding, or discovering things that we don't know, certainly we

have kind of a typical academic area that we can think of. So, in terms of my area, arts research in an academic way might be writing articles, presenting scholarly papers at conferences, doing quantitative or qualitative research of some kind and attempting to then disseminate that information in a way to enrich the discipline. I think also, arts research, can be in the area of performance, so often times performing can be, I think, a form of research—performances, practices, creating, composing, in my area of music. I think teaching can come into that realm as well, not only research about teaching but the process of teaching in my opinion is always a matter of research. There's a great deal as you work with students that you don't know and so in my opinion a good professor, a good teacher, is always working to learn and to use that information as the teaching process to the class evolves. I think arts research includes academic research, it includes performance, it includes education, that's all part of research in my opinion."

"I think arts research can be — part of what happens in art research is research that would be readily recognized as being quite similar to what happen, say, in an English department or a history department. So we are having scholars who are writing — writing scholarly work. I think that's the kind of typical humanities research. And some scholars who are based in arts departments do that kind of research on the arts. But I think and in addition to that, artistic research university settings like this is what artists are doing in terms of making new works of art, new original works of art that are speaking to issues that they care about. It might be issues of the community, issues of our time, issues of another time, but in that kind of originality, the expectation of originality is definitely in there. And then in answering your question I don't want to set up a binary of like, either you are doing scholarly work or its artistic work. There are many people for whom it all matches together, where the researchers kind of think of it as multi-platform, expressing itself from many different medium."

"I don't really think about arts research. I think about arts as a process that gives us a lot of information that can be used in many different ways by many different people, but I don't really think of it as research."

"I think the same thing. I think, in a lot of ways, research is research. Artists do a lot of the same things that scientists do. They do a lot of the same things that mathematicians do. They have particular area of interest and a particular set of skills and they ask questions about those particular areas of interest and expertise and go where it takes them."

"Arts research to me has a number of different meanings. It can mean understanding arts themselves, what is required for carrying out various processes for creating art, whatever form it may be. You could think about in a number of levels; you could think about the motivation involved, the interest, the emotion, but then you can also thing about the cognitive processes. Given my background, that's sort of the way I think about it. Arts research can also be using art as a means to ask other questions, and this is largely what my research does. My research is based on the case study of an individual who unfortunately had a virus attack her brain and had extreme brain damage. Prior to her illness, she was a professional illustrator, published numerous works in *New York Times*, she had *New Yorker* covers, she I think illustrated 50-some books, a very well-to-do illustrator and she had this virus attack her brain. As a result of the virus, she has severe amnesia, so she has incredible memory impairment. For example, every time she meets me, it's as though she's meeting me for the first time and she remembers very little of her past. When we ask, or the example we usually give when we ask her about her husband. She doesn't even remember, she was married for ten years, okay? Given her experience in art, we have used that as a means, to test what parts of her memory are severely impaired, but what parts are spared? Not only was she an illustrator and visual artist, but she also happened to be a musician, an amateur musician. We can ask about art and use art from a number of different perspectives to test what she can and cannot do. I see that not so much. There's two things that come out of this research. We ideally are interested in studying learning and memory, but we can use art as a way to test that. We've found that although she can't remember, if I show her a McDonald's logo, she has no idea what it's associated with. But yet when I ask her ... Even if you don't want to, you see that logo many times in your life. In 50 years of experience, you have many occasions where you see it. Yet when

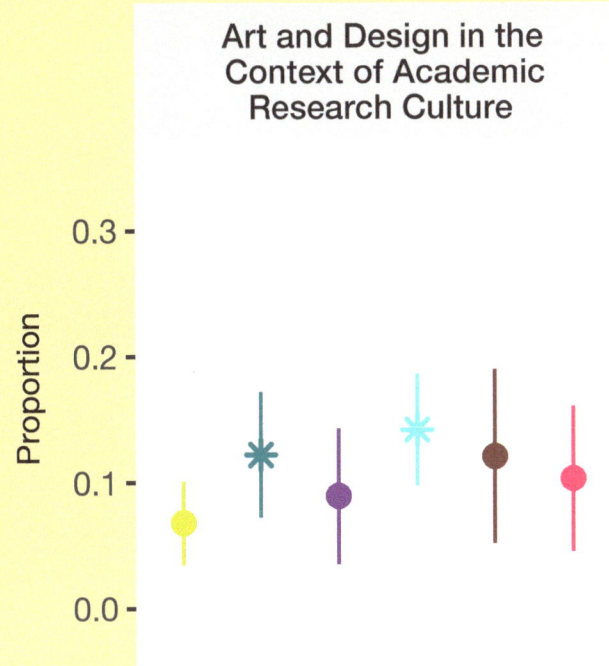

Above: Topic prevalence by discipline clusters for the topic "Art and Design in the Context of Academic Research Culture" Perhaps fittingly and self-reflective, the Fine Arts and Music clusters included this topic in their responses somewhat more than others.

I ask her question about how you would produce a wash in watercolor, she gives me a completely accurate description and she can carry it out. Not only doing it, but describing it. It's not all art, so when you ask her about, show her famous paintings like Monet's *Waterlilies* or Van Gogh. She can't tell you anything about those paintings, yet you know as a professional artist, someone who had earned a BFA early on, had the opportunity to teach some art, had a mother who was an artist growing up, you know she knew that information. Yet, you see these interesting dissociations. In using her expertise in these particular art areas, we're able to study what information is still there and that brings the interesting question up, which is, why are certain aspects of her memory of her previous life still there and what is it about them? Is it because they had to do with creative expression? Is it because she used them more frequently? In that way, art has been an extremely useful tool for me to ask questions about memory and learning in this individual."

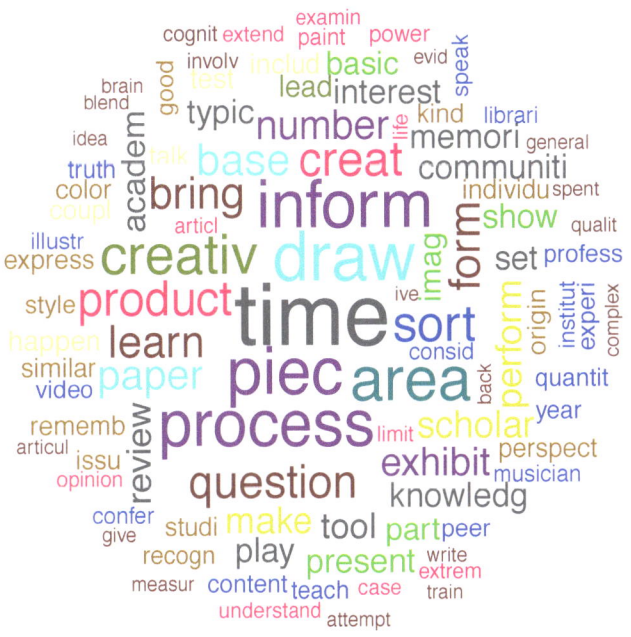

Above: A word cloud for the topic "The Arts and Design in the Context of Academic Research Culture" with words weighted by their probability. Larger words represent higher probability words for the topic, and color contrasts help distinguish probability levels.

ARTS RESEARCH:
Design Research

FROM EMPATHY TO INNOVATION

> " For myself, I really see design as a mode of inquiry that produces knowledge through the process of making ... It can. It doesn't have to, but it can have that intention, and it's a different style of inquiry than engineering and scientific research."

ASSOCIATE PROFESSOR
INTERACTION DESIGN

> " I don't think I would distinguish the two, arts research and design research."

ASSISTANT PROFESSOR
ARCHITECTURE

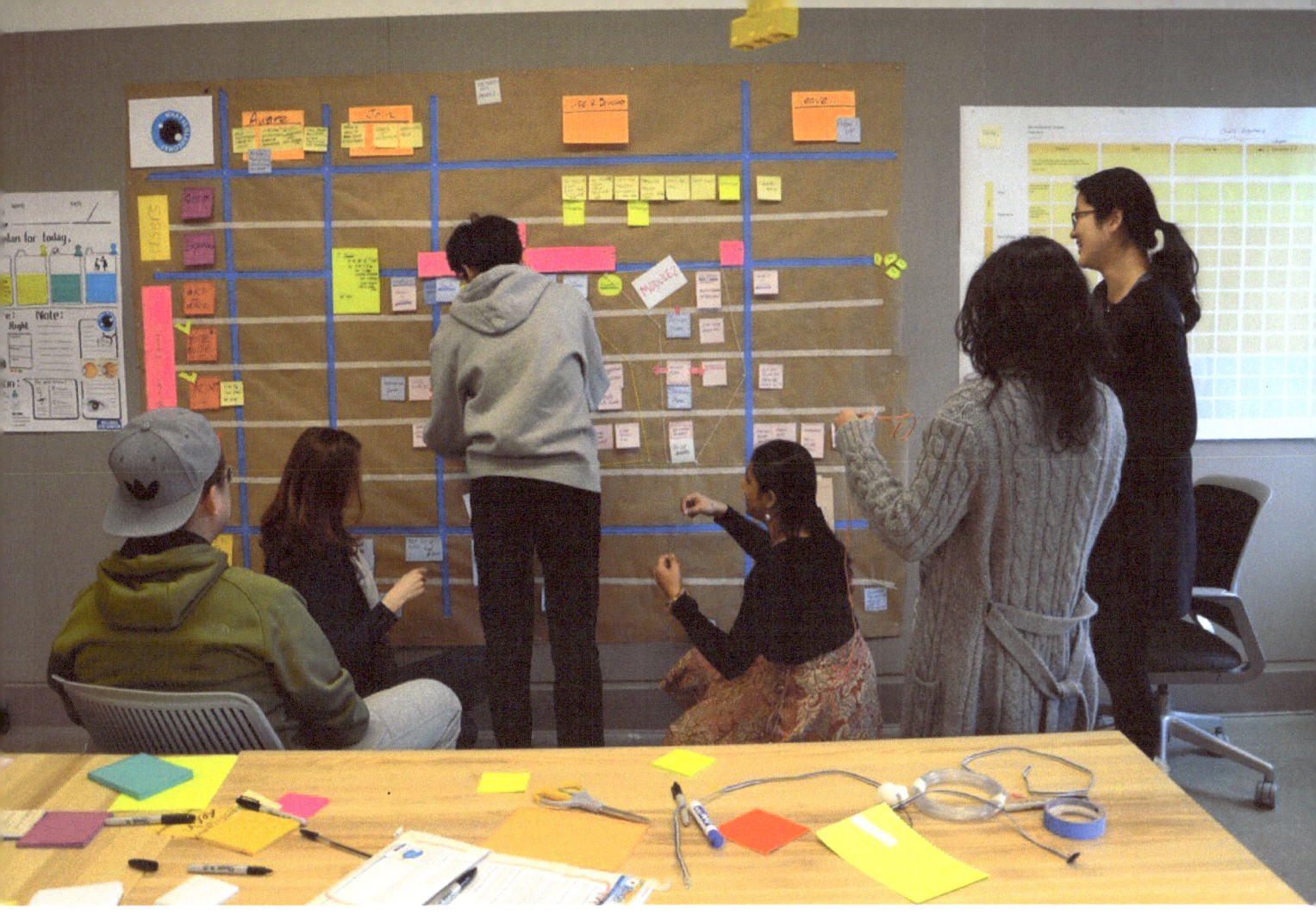

Above: MDes graduate student researchers analyze insights and techniques to help medical technicians facilitate productive conversations with patients about medication adherence. Students in the MDes program in Integrative Design at the University of Michigan focus on design process as a way to link design research and design practice. Photo Credit: John Marshall.

Sometimes called holistic design or integrative design, design research is often conceived and practiced as an active interdisciplinary approach, drawing from whatever influences, techniques, and resources are most germane to the problem at hand.

"Interdisciplinary arts is a kind of research that draws insights from more than one discipline in order to contribute to knowledge formation."

"I understand arts research to be such pursuit of knowledge either with the plan of vetting the work in an explicitly arts-oriented discipline, or I understand arts research to be the employment or borrowing of techniques and methodologies from the arts for the production of knowledge for vetting in other disciplines."

"For myself, I really see design as a mode of inquiry that produces knowledge through the process of making. It can. It doesn't have to, but it can have that intention, and it's a different style of inquiry than engineering and scientific research."

"Design can be maybe looking at a current situation and beginning to imagine or hypothesize a preferred solution to that problem."

"Let me tell you a story, and then let's see if I can lead up to the answer. I started working with, actually, students from the School of Design about twenty years ago. They became part of our design teams as we built, in this case, we would call wearable computers - computers that people took information with them out onto the job site. They had to be easy to use, aesthetically pleasing, very intuitive. The design students actually brought a holistic approach to it, whereas the engineers would build boxes. They actually did some studies on where on the body you could mount the equipment, with its shape, with its weight, with heat production. They

came up with about a dozen rules, and those were then used as guidelines by other people designing electronics that you wear on the body. When I've worked with designers, they've been defining the research through doing design. In other words, they will populate a space - in this case, wearable computers - with lots of different examples using their best holistic and intuitive approaches, and then after a while sit back and try to codify what they discovered, so that other people who aren't as schooled in their disciplines. One thing I found, at least working with the School of Design students, is they were more fearless than the engineers. The engineers were more conservative. They would do things the way it had been done before, and often, the designers would be exploring new manufacturing techniques, new textures, new concepts. I'll just give you one simple example of how the two came together. In their discovery of wearable computers, they found out that people sort of change the way they moved if you had something that stuck out more than two inches off your body. What happened: we were designing a computer, and trying to keep within that two inch limit wasn't what the current electronics technology allowed. You have two boards, and then you have a connector between the boards - and that stack just stuck out more than two inches. They went back to the engineers, and said, "Well, is there any way that you can take two circuit boards and use an inner layer of the board to connect the boards, and make it flexible like a ribbon cable?" They went to the people who manufactured the printed circuit boards, and they said yeah, they could do that. Then we pass it and fold it over like a taco, and you can put your wireless radio in between, and it met the two inch limit. It inspired some technology changes that the engineers had discovered. The fact that they're working together, they come up with new concepts that each individual discipline wouldn't have come up with by themselves."

Arts research is akin to design research, which emerged as a practice in concert with engineering, architecture, and applied scientific modes of problem solving. Design research is well described in the literature, with journals, professional associations, and practicing firms devoted to the practice. Design research frequently involves systematic, codified, easily transmitted and acquired heuristics and routines for recognizing, understanding, formulating, and solving problems.

There tends to be distinct attention to users, audiences, clients, or "recipients" of the design process, and this can entail explicit methodologies and practices imported from the social sciences or developed along the way as an addition to the design researcher's "toolbox."

"Design research I believe is sort of a big can of worms. It has been defined by different people over the years in different ways. I'd probably go back to Leonardo da Vinci—well, before him, 3,000 years before in Chinese culture and other cultures in the west, was not really separated from arts research, or from technical analytic work. In fact, they were united. It's only recently that we have disunited them. If you go—let's just start closer to today—the Renaissance to today, it's been pulled apart, so that now design research has over several decades meant different things to different people. I think in the post-World War II industrialization of America, design research came to mean, "How can the means of production be made more and more efficient and effective?" I think Operations Research, Industrial Engineering, and then of course all branches of Engineering, do design research to some extent. It can be boiled down, and has been by a variety of authors, into conceptual design and detail design. They also say two phases, where the upstream phase is identifying customer needs, wants, and desires, putting in the context around a given design problem. Then the detail design would be the steps of figuring out alternative solutions to the articulated challenge, and then detail design: size of bolts, size of the paintbrush, whether you want to use a pointillist approach or an impressionistic approach to get across a certain marketing point if you're in a marketing firm, and so on and so forth. I think design research is just a very broad swath today that's interpreted differently by the traditional discipline that you reside in. Engineers interpret it one way. I think architects interpret it a different way. People in the arts often don't use the term, but actually engage in design research when they're thinking of how to fill the empty canvas. They actually do design research, but they don't call it design research. People in medicine do design research when they come to work in the morning and decide what to do in their laboratory. Do I study the stem cell and the cardiac tissue, or do I work on a given gene? They actually engage in design research when they ask their next hypothesis, and then use scientific methods to

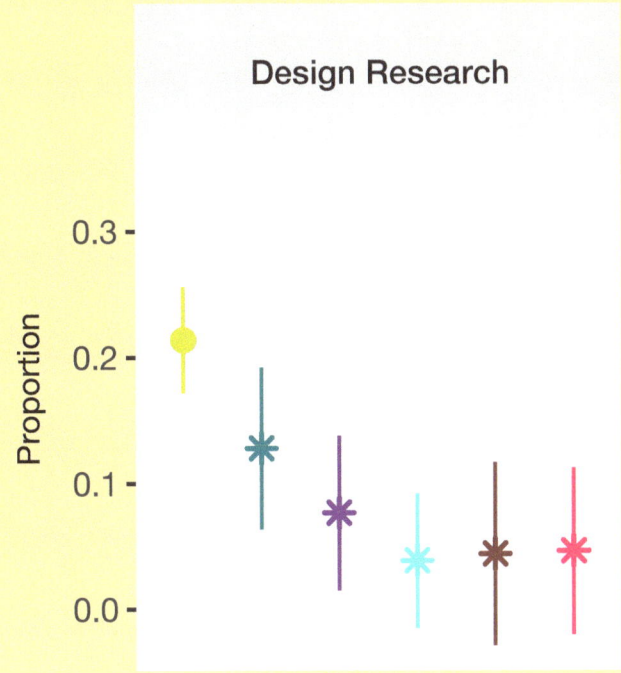

Above: Topic prevalence by discipline clusters for the topic "Design Research." Of all of the topics that emerged, this one appears to be the most driven by the design-driven cultures of engineering, design, information, and architecture.

address the validity of the hypothesis. They don't call it design research; they call it hypothesis testing. To me, it's a very broad term, that encompasses many, many disciplines' actual behaviors but is not used by all disciplines in an explicit way."

"I suppose a lot of it is problem definition, research, synthesis and integration, prototyping, testing, and then hopefully reiteration. I think design research is, in a perfect world, very akin to software development in its circular process and its assumption that you've never really solved the problem. You're simply undertaking a process of iteration and synthesis and recontextualization."

"…arts research always involves the activation of process or knowledge towards the acquisition of new process and knowledge. So, you know, for me, art research -- it's implicit that some sort of activity prototyping testing activation is the key component. So you are kind of connecting the intent with the purpose and the outcome of knowledge production a little bit more intimately than I think in other disciplines."

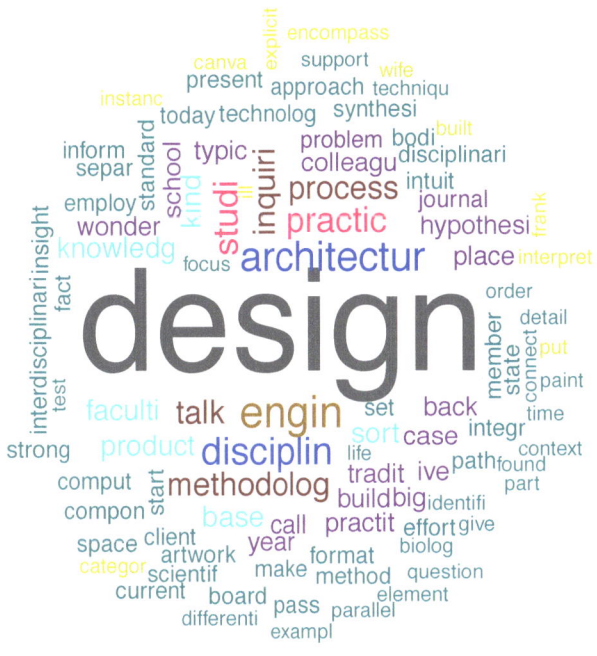

Left: A word cloud for the topic "Design Research" with words weighted by their probability. Larger words represent higher probability words for the topic, and color contrasts help distinguish probability levels.

INSIGHTS

Topic Prevalence by Discipline Clusters for Each Topic

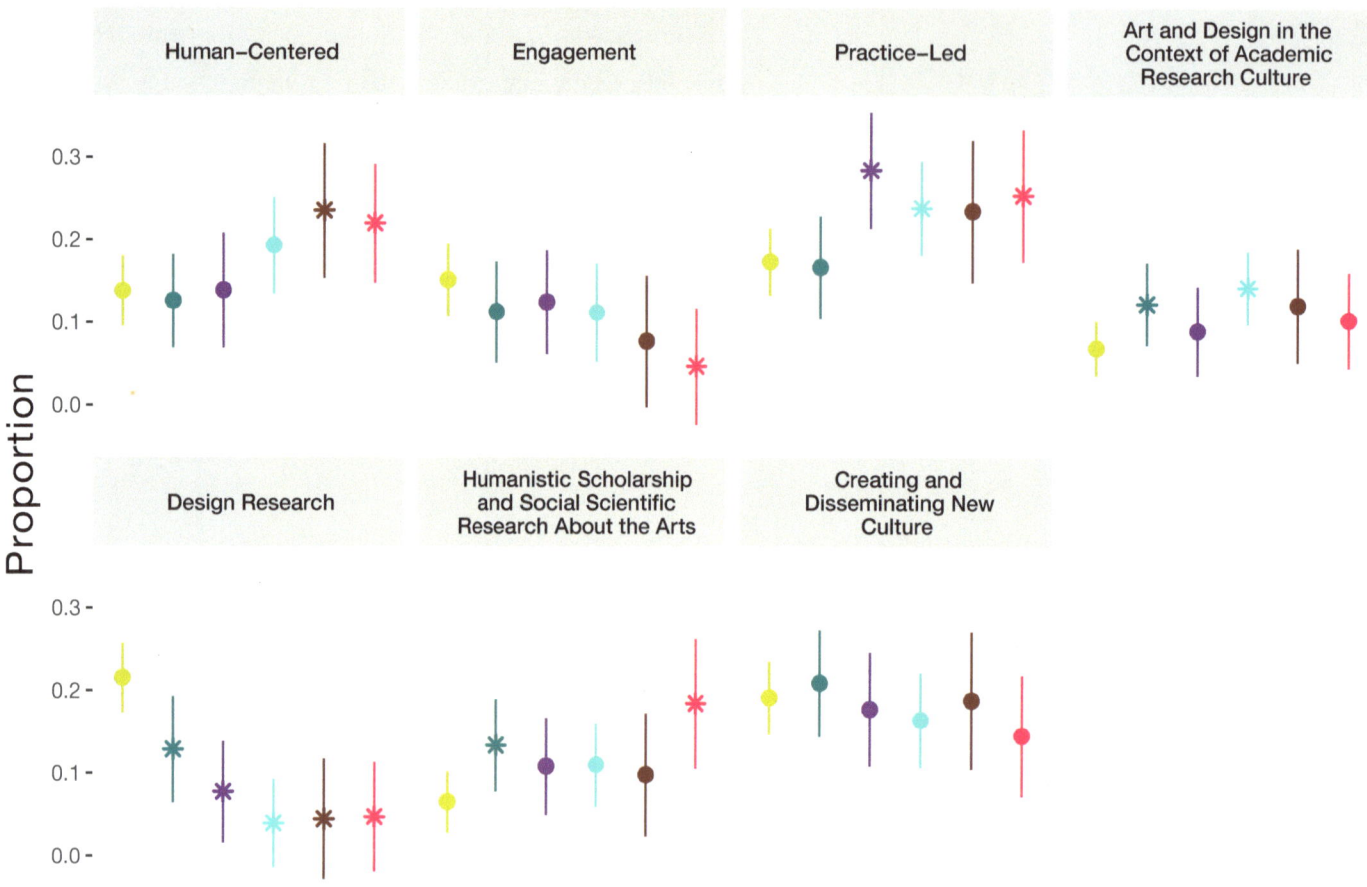

The figures above compare discipline clusters by the prevalence of each topic. The "Engineering" discipline cluster was used as the intercept in the model, serving as the base level for comparison. Some topics, such as "Design Research" match well with relevant disciplines. "Creating New Culture" is both prevalent and cross-cutting.

Primary Discipline

- Engineering, Design, Information and Architecture (n=99)
- Fine, Contemporary and Media Arts (n=92)
- Humanities (n=63)
- Music, Theatre, and Dance (n=108)
- Natural Sciences and Medicine (n=36)
- Social Sciences, Education, Business and Law (n=46)

Significant Difference?
● Not Sig. ✱ $p <= .05$

Topic Prevalence by Topic for Each Discipline Cluster

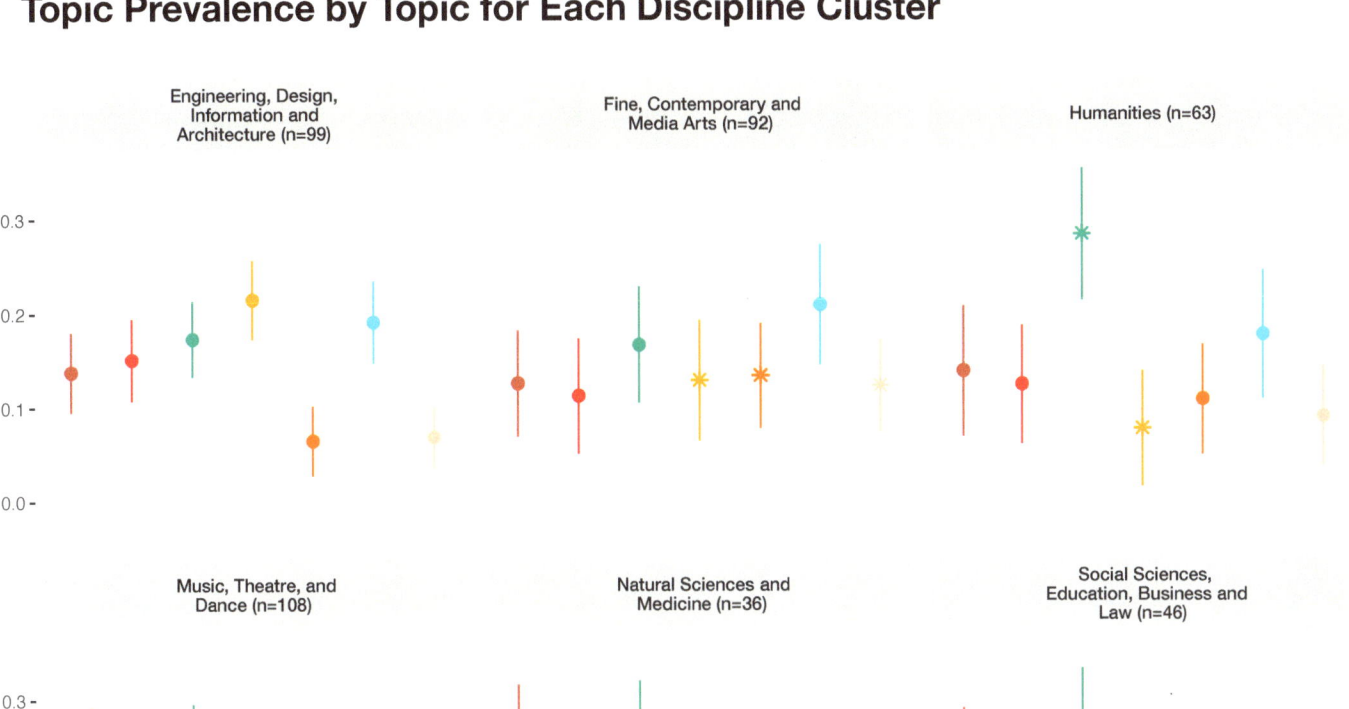

Topic comparisons redrawn to partition and show their relative proportions within discipline clusters. Significance marks refer to between-discipline differences and are the same as shown on page 35. What this helps show, for example, is that the Social Sciences cluster exhibits differences from other discipline clusters in five of the seven topics. It also elps show which topics are more likely to be a part of the discourse in a disciplinary cluster. For example, the Humanities have a larger prevalence of the "Practice-Led" topic, while the Engineering cluster has a relatively higher proportion of "Design Research."

METHODS

Data Collection
Semi-structured interviews (Mackh, 2015) were recorded on video, transcribed to text (Rev, Quickscribe), cleaned of information that would directly identify interviewees, assembled into discrete question-and-response pairs, and parsed onto data sheets with metadata about their institutions. Full-text interviews and data sheets are archived at the National Archive of Data on Arts and Culture (NADAC).

Primary Data and Analysis
Responses to the question *"What do you understand arts research to be?"* provided 444 full-text responses across 38 institutions of higher education as the primary dataset.

In order to make summary comparisons, additional metadata variables were derived in OpenRefine to group respondents by discipline-based clusters that share some cultural similarities (pp. 37-38 of this brief). The table below shows the total number of individual responses for each disciplinary cluster used as a factor level in the analysis.

Discipline Cluster	n respondents
Engineering, Design, Information, and Architecture	99
Fine, Contemporary, and Media Arts	92
Humanities	63
Music, Theatre, and Dance	108
Natural Sciences and Medicine	36
Social Sciences, Education, Business, and Law	46

We employed a probabilistic topic modeling approach (Roberts et al., 2014, 2018) to provide machine-assisted reading and categorization of the interview response texts. Probabilistic topic modeling is a constellation of statistical methods that analyzes the words of original texts to discover, sort, and connect their themes.

Interpretation Notes and Discussion
Heteroglossia is the co-occurrence of perspectives, ideas, or modes of expression within single responses (Bakhtin, 1982; DiMaggio, 2013), and it is common among these interview responses. The responses were often mixtures of topics that included a variety of motivations, practices, histories, and cultural contexts. Nonetheless, in separating out distinct topics, clear patterns emerged in the types and distribution of topics observed.

In addition, some topics tended to co-occur less often than others, as shown by the dendrogram on page 3. For example, engagement-driven modes of arts research (engagement and design research), are somewhat less closely aligned with research *about* the arts.

For the Fine, Contemporary, and Media Arts clusters, there was lower variation overall between topic proportions; each topic was within a .1 range of the others (pg. 36). In comparison, other disciplinary clusters had starker differences in the proportions of topics. This result suggests that disciplinary affiliations and vantage points provide a lens to interpret the motivations and practices of arts-based research. Moreover, disciplines other than the fine, contemporary, and media arts may

define and engage with arts-based research by preferentially excluding some motivations and topics and including others.

Some factors are likely to affect the patterns that emerged. As evidenced by the diversity in topics and across the various disciplines, the definition of arts research is not uniform or homogeneous, suggesting that it is not widely and commonly understoood. Cognitive factors such as the level of expertise and individual experiences of the individuals sampled may result in a more or less nested hierarchical branching pattern in the tree diagram on pages 3-4, as well as differences in the coherence (uniformity) of each topic description. The relative proportion of each topic in the topic distribution may also change from group to group as a function of sample size and group identity. And finally, the domain experience and interpretive skill of those analyzing the results and texts may somewhat influence the categorization of each topic.

Despite these factors, it's reasonable to expect that the overall shape and general identity of the topics should remain relatively stable from group to group, provided a reasonable enough sample. The topics that emerged in this analysis are general enough to reflect contemporary knowledge and discussions of the domain. For example, relational aesthetics (Bourriaud, 2002) and social practice-based work (Thompson, 2012) in the visual arts could easily be described as facets or mixtures of both the "Engagement" and "Practice-Led" topics.

Future work could investigate additional levels of description and detail for each of the topics described here, as well as examples of the types of work that fall into each of the seven topic areas, brief literature reviews for each topic, example syllabi for teaching, and more detailed description of how specific disciplines map their practices to each topic area. This kind of approach could prove especially useful in surfacing examples for comparison, shaping language and communication, and fostering critical reflection and judgment about interdisciplinary modes of research and practice.

Methods References

Bakhtin, M. M. (1982). *The dialogic imagination: Four essays.* (M. Holquist & C. Emerson, Trans.). Austin, TX: University of Texas Press.

Bourriaud, N. (2002). *Relational aesthetics.* Dijon: Les presses du réel.

DiMaggio, P., Nag, M., & Blei, D. (2013). Exploiting affinities between topic modeling and the sociological perspective on culture: Application to newspaper coverage of U.S. government arts funding. *Poetics*, 41(6), 570-606.

Mackh, B. M.. (2015). *Surveying the landscape: Arts integration at research universities.* Ann Arbor, MI: ArtsEngine, University of Michigan.

Thompson, N. (Ed.). (2012). *Living as form: Socially engaged art from 1991-2011.* MIT Press.

Roberts, M. E., Stewart, B. M., Tingley, D., Lucas, C., Leder-Luis, J., Gadarian, S. K., . . . Rand, D. G. (2014). Structural topic models for open-ended survey responses. *American Journal of Political Science.* 58(4), 1064-1082.

Roberts, M., Stewart, B., & Tingley, D. (2018). stm: An R package for Structural Topic Models. [http://www.structuraltopicmodel.com]

METHODS

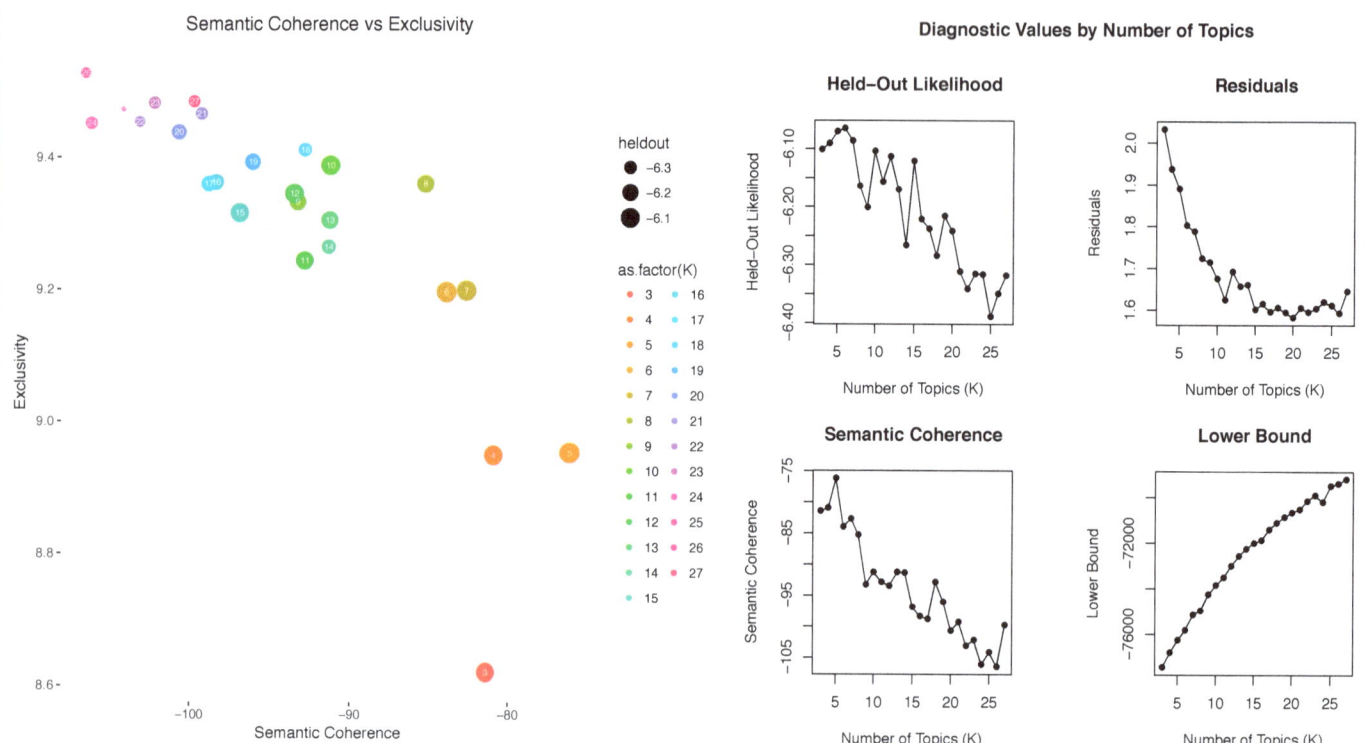

Diagnostic Information for Selecting Topic Number and Model Fit

The figures above show a series of plots with diagnostic information used to help select the number of topics that provide the best model to fit for data. A range of models was explored to find one that provided the best held-out likelihood while also balancing trade-offs between the semantic coherence of each topic and the level of exclusivity that distinguishes each topic (top left; Roberts et al., 2014, 2018). In general, models with higher held-out likelihood suggest a better fit with the data, while the complementary estimates of semantic coherence and exclusivity provide insight into the quality of the model. It was also important to incorporate a close reading of the interview texts—coupled with researchers' domain knowledge—to select an appropriate number of topics for the model. Using understanding of the culture(s) of research universities and of arts research as the domain being studied, a model with seven topics was selected.

METHODS

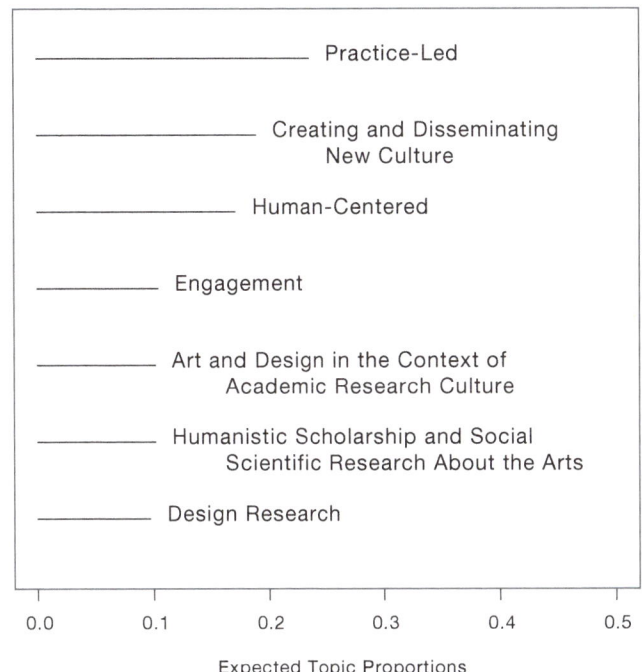

Interpreting the Topics

Each of the candidate topics was verified, labeled, interpreted, and described using high probability terms provided by the model and the full texts from the top 21 interview responses for each topic. High probability terms for each of the seven topics and their expected topic proportions are shown here (left) as a distribution across the entire corpus of responses. A research panel of domain area experts read, interpreted, and discussed interview responses and keywords, providing insight and interpretive diversity for labeling the topic identities. Topics were then labeled for simplicity and clarity (right). The resulting topics do not provide an exhaustive taxonomy for arts research. Instead, they provide a basic set of categories to help communicate more specifically what is meant by arts research.

A SAMPLE OF BOOKS AND ARTICLES ABOUT ARTS RESEARCH

SCHOLARSHIP AND RESEARCH ABOUT AND THROUGH THE ARTS

Biggs, M., & Karlsson, H. (Eds.). (2010). *The Routledge companion to research in the arts.* Routledge.

The Routledge Companion to Research in the Arts addresses the diversity of views on what constitutes arts-based research and scholarship; communication difficulties arising from terminological and ontological differences; traditional and non-traditional concepts of knowledge, their relationship to professional practice, and their outcomes and audiences; a consideration of the role of written, spoken and artifact-based languages in the formation and communication of understandings.

DiMaggio, P. (1987). Classification in art. *American Sociological Review*, 52(4), 440-455.

A framework is proposed to analyze the relationships between social structure, patterns of artistic consumption and production, and the ways in which artistic genres are classified. This framework helps to integrate findings of consumption surveys and to explain the emergence of new artistic genres as a form of ritual classification.

Chilton, G., & Leavy, P. (2014). Arts-based research practice: Merging social research and the creative arts. *The Oxford Handbook of Qualitative Research,* 403-422. Oxford University.

This chapter provides a retrospective and prospective overview of the field, including a review of some of the pioneers of arts-based research, methodological principles, robust examples of arts-based research within different artistic genres, assessment criteria, and the future of the field.

O'Donoghue, D. (2009). Are we asking the wrong questions in arts-based research? *Studies in Art Education*, 50(4), 352-368.

This article identifies what is different and similar in, between, and across art and educational research, and suggests ways forward to imagine possibilities for what arts-based research offers for inquiring into the educational worlds.

Barone, T., & Eisner, E. W. (2011). *Arts Based Research.* Sage.

The book address key aspects of arts based research, including its purpose and fundamental ideas, controversies that surround the field and the politics and ethics involved, and criteria for evaluation.

Baden, M. S., & Wimpenny, K. (2014). *A Practical Guide to Arts-related Research.* Springer.

This book outlines the principles and practices of arts-related inquiry and provides both suggestions about conducting research in the field as well as case study examples.

Rolling, J. H. (2013). *Arts-based Research Primer.* Peter Lang GmbH.

The Arts-Based Research Primer explores the arts-based research paradigm and its potential to intersect with and augment traditional social science and educational research methods.

Lovano-Kerr, J., & Rush, J. (1982). Project Zero: The evolution of visual arts research during the seventies. *Review of Research in Visual Arts Education*, 8(1), 61-81.

The focus of Project Zero has been the developmental study of artistic growth and the ability of persons to use and understand various kinds of symbols, their importance in general cognition, and fresh insights into the overall educational process.

McNiff, S. (2008). Art-based research. *Handbook of the arts in qualitative research: Perspectives, methodologies, examples, and issues.* Sage.

Art-based research can be defined as the systematic use of the artistic process, the actual making of artistic expressions in all of the different forms of the arts, and as a primary way of understanding and examining experience by both researchers and the people that they involve in their studies.

CREATING AND DISSEMINATING NEW CULTURE

Golden, T. (2009). How Art Gives Shape to Cultural Change. TED. https://www.ted.com/talks/thelma_golden_how_art_gives_shape_to_cultural_change.

Thelma Golden, curator at the Studio Museum in Harlem, talks through three recent shows that explore how art examines and redefines culture. The "post-black" artists she works with are using their art to provoke a new dialogue about race and culture -- and about the meaning of art itself.

Bourdieu, P. (1993). *The Field of Cultural Production: Essays on Art and Literature*, (R. Johnson, Ed.). Polity Press.

Bourdieu elaborates a theory of the cultural field which situates artistic works within the social conditions of their production, circulation, and consumption. He examines the individuals and institutions involved in making cultural products what they are: not only the writers and artists, but also the publishers, critics, dealers, galleries, and academies. He analyzes the structure of the cultural field itself as well as its position within the broader social structures of power.

Rose, K., Daniel, M. H., and J. Liu. (2017). *Creating Change through Arts, Culture, and Equitable Development: A Policy and Practice Primer.* PolicyLink.

Arts and culture enable understanding of the past and envisioning of a shared, more equitable future. Arts and culture act as tools for community development, shaping infrastructure, transportation, access to healthy food, and other core amenities. Arts and culture contribute to strengthening cultural identity, healing trauma, and fostering shared vision for community.

HUMAN-CENTERED

Schulkin, J., & Raglan, G. B. (2014). The evolution of music and human social capability. *Frontiers in Neuroscience,* 8, 292.

Music is a core human experience, and it can promote well-being by facilitating human contact, meaning-making, and imagination of possibilities, tying it to our social instincts. This paper focuses on the intersection between the neuroscience of music, and human social functioning to illustrate the importance of music to behavior.

Whitehead, F. (2006). What do Artists Know? http://embeddedartistproject.com/What_do_artists_know.pdf

Beyond a wide range of material practices, histories and techniques, concepts and theoretical frameworks, artists are trained to use a unique set of skills, process, and methodologies.

Schulz, A. (2005). *Goya's Caprichos: Aesthetics, Perception, and the Body.* **Cambridge University Press.**

This book is a detailed analysis of the artistic principles and the role of vision and perception that animate a collection of images, and the particular historical moment in which the prints were created and first received.

Feral, J. (2012). How to define presence effects : the works of Janet Cardiff. *Archaeologies of Presence.* **Routledge.**

By 'presence effects,' one means the feeling of a body's (or an object's) presence – that these bodies or objects create the impression of really being there, even if the audience rationally knows that they are not. What constitutes this presence or presence effect? This article disentangles the different meanings of presence through various disciplines: from the performing arts (theatre and dance) to the media and digital arts.

ENGAGEMENT

Riley, S. R., & Hunter, L. (2009). *Mapping Landscapes for Performance as Research: Scholarly Acts and Creative Cartographies.* **Springer.**

Although the sciences have long understood the value of practice-based research, the arts and humanities have tended to structure a gap between practice and analysis. This book examines differences and similarities between Performance as Research practices in various community and national contexts, mapping out the landscape of this new field.

Gablik, S. (1984). *Has Modernism Failed?* **Thames and Hudson.**

Arguing for a renewed moral, social and spiritual dimension in art, Gablik points to some encouraging developments and the attempts of artists to integrate the concerns of the environment and the world with their art.

Denzin, N. K. (2003). *Performance Ethnography: Critical Pedagogy and the Politics of Culture.* **Sage.**

Performance ethnography serves as an invitation for social scientists and ethnographers to confront the politics of cultural studies and explore the multiple ways in which performance and ethnography can be both better understood and used as mechanisms for social change and economic justice.

Finley, S. (2011). Critical arts-based inquiry. *The SAGE Handbook of Qualitative Research*, 435-450.

Critical arts-based inquiry is characterized by its integration of multiple disciplines and discourses. Similarly, critical arts-based researchers facilitate community-based performances that reconstruct or blur both physical and abstract boundaries.

Avdeeff, M. (2014). Young People's Musical Engagement and Technologies of Taste. *Mediated Youth Cultures*, 130-145. Palgrave Macmillan.

Through the results of a large-scale, empirical study, this chapter explores how taste and sociability are highly intertwined, with boundaries becoming increasingly blurred between people and technology, music and genre definitions, and artist and fan.

Tepper, S. & Ivey, W. (Eds.) (2008). *Engaging Art: The Next Great Transformation of America's Cultural Life.* **Routledge.**

Engaging Art explores what it means to participate in the arts in contemporary society – from museum attendance to music downloading. This volume analyzes key trends involving technology, audience demographics, religion, and the rise of "do-it-yourself" participatory culture to offer a new framework for understanding the changes impacting America's cultural life over the past fifty years.

PRACTICE-LED

Sullivan, G. (2010). *Art Practice as Research: Inquiry in the Visual Arts.* **Sage.**

Art Practice as Research argues that the creative and cultural inquiry undertaken by artists is a form of research, that legitimate research goals can be achieved by choosing different methods than those offered by the social sciences, and that artists emphasize the role of the imaginative intellect in creating, criticizing, and constructing new knowledge and understanding.

Smith, H., & Dean, R. (Eds.). (2009). *Practice-Led Research, Research-Led Practice in the Creative Arts.* **Edinburgh University Press.**

Practice-Led Research, Research-Led Practice in the Creative Arts considers how creative practice can lead to research insights through what is often known as practice-led research and posit an iterative and web-like relationship between practice and research.

Grant, K. (2017). *All about Process: The Theory and Discourse of Modern Artistic Labor.* Penn State Press.

Many prominent and successful artists have claimed that their primary concern is not the artwork they produce but the artistic process itself. In this volume, Grant analyzes this idea and traces its historical roots, showing how changing concepts of artistic process have played a dominant role in the development of modern and contemporary art.

Gray, C. and Malins, J. (2004). *Visualizing Research: A Guide to the Research Process in Art and Design.* Ashgate.

Visualizing Research aims to guide postgraduate students in Art and Design through the research process, using the metaphor of a 'journey of exploration'. The book may be used in conjunction with a formal programme of study - from masters to doctoral level - in the development and implementation of a research project.

Vaughan, L. (2017). *Practice-Based Design Research.* Bloomsbury Academic.

Practice-Based Design Research addresses a range of models and approaches to practice-based research, considering relationships between industry and academia, researchers and designers; discusses initiatives to support students and faculty during the research process, and explores how students' experiences of undertaking practice-based research has impacted their future design and research practice.

IN THE CONTEXT OF ACADEMIC RESEARCH CULTURE

Singerman, H. (1999). *Art Subjects: Making Artists in the American University.* University of California Press.

Arguing that where artists are trained makes a difference in the forms and meanings they produce, Singerman shows how the university, with its disciplined organization of knowledge and demand for language, played a critical role in the production of modernism in the visual arts. Now it is shaping what we call postmodernism: like postmodernist art, the graduate university stresses theory and research over manual skills and traditional techniques of representation.

Frayling, C. (1994). Research in Art and Design. Royal College of Art Research Papers, Vol 1, No 1, 1993/4.

Differentiating what research is in the context of arts and design.

Borgdorff, H. (2016). The conflict of the faculties. *Perspectives on Artistic Research and Academia.* Leiden University Press.

The Conflict of the Faculties looks at the emerging field of artistic research as a place of crossover between the artistic and academic worlds. Henk Borgdorff carefully examines how artistic research broadens and deepens traditional academic approaches to studying art, while observing the tension.

Bast, G., Carayannis, E. G., & Campbell, D. F. (Eds.). (2015). *Arts, Research, Innovation and Society.* Springer International Publishing.

Creativity in general and the arts in particular are increasingly recognized as drivers of cultural, economic, political, social, and scientific innovation and development.

Macleod, K. and Holdridge, L. (Eds.). (2006). *Thinking Through Art: Reflections on Art as Research* (Innovations in Art and Design Series). Routledge.

Focusing on a unique arena, *Thinking Through Art* takes an innovative look at artists' experiences of undertaking doctorates and asks: If the making of art is not simply the formulation of an object but is also the formation of complex ideas, then what effect does academic enquiry have on art practice?

Chapman, O. B., & Sawchuk, K. (2012). Creation: Intervention, Analysis and "Family Resemblances". *Canadian Journal of Communication*, 37(1).

"Research-creation" is an emergent category within the social sciences and humanities that speaks to contemporary media experiences and modes of knowing. Research-creation projects typically integrate a creative process, experimental aesthetic component, or an artistic work as an integral part of a study. The focus of this article is how this practice contributes to the research agenda of the digital humanities and social sciences.

DESIGN RESEARCH

Laurel, B. (2003) *Design Research: Methods and Perspectives.* M.I.T. Press.

How the tools of design research can involve designers more directly with objects, products and services they design; from human-centered research methods to formal experimentation, process models, and application to real world design problems.

O'Grady, J. V., & O'Grady, K. (2009). *A Designer's Research Manual: Succeed in Design by Knowing Your Clients and What They Really Need.* Rockport Publishers.

This book provides a comprehensive manual for designers on what design research is, why it is necessary, how to do research, and how to apply it to design work.

Krippendorff, K (2006) *The Semantic Turn.* CRC Press, Taylor & Francis Group.

The Semantic Turn reviews the history of semantic concerns in design, presents their philosophical roots, examines the new social and technological challenges, and offers distinctions among contemporary artifacts that challenge designers. It also provides concepts and a vocabulary that enables designers to better partner with engineering, ergonomics, ecology, cognitive science, information technology, management, and marketing.

FOLLOW-UP: QUESTIONS AND TASKS FOR BUILDING UNDERSTANDING

For each category of arts research, try to identify three examples from your institution.

For each category of arts research, try to identify and compare three different examples from somewhere else.

For each category of arts research, what are the shared methods and/or practices that are common to your examples?

What kinds of things does each type of arts research do to establish its credibility, trustworthiness, and impact on others? How are these communicated?

What instructional, teaching, and/or learning activities would be relevant for deepening understanding and expertise in the category?

What kinds of institutional barriers might get in the way of each type of arts research activity?

What kinds of incentives or programs could encourage ongoing integration among different forms of arts research?

Compare and contrast each type of arts research. What communications challenges might potential collaborators face when encountering others who have a different view? How might collaborators clarify, negotiate, or resolve their differences?

PRACTICE

FOLLOW-UP: QUESTIONS AND TASKS FOR INTEGRATION AND PRACTICE

Applying the results of this research to practice can unfold in many ways. Some of the easiest applications involve using the categories for program development and criteria, as well as domain areas for syllabi and teaching. The categories described in these pages are prototypical, and they will continue to be refined and developed as new examples and perspectives are added.

Consider how you might apply and integrate the examples of arts research to develop:

- a conference or symposium
- a course sequence or syllabus
- collaborative, team-based projects
- criteria for requests for proposals (RFPs) or grantmaking
- seeds for discussion of criteria for reappointment, promotion, or tenure
- individual class or studio-based assignments and activities
- facilitated sensemaking sessions for your group, department, or college
- messaging and language for communications to different audiences
- case-making and advocacy materials for building awareness
- timelines or evaluation strategies for arts research projects
- a map of existing art research activities
- research strategy for the arts and design in your institution
- improved arts and design research foundations training modules

www.ingramcontent.com/pod-product-compliance
Lightning Source LLC
Chambersburg PA
CBHW041320180526
45172CB00004B/1172